Bullet Trains to Yaks

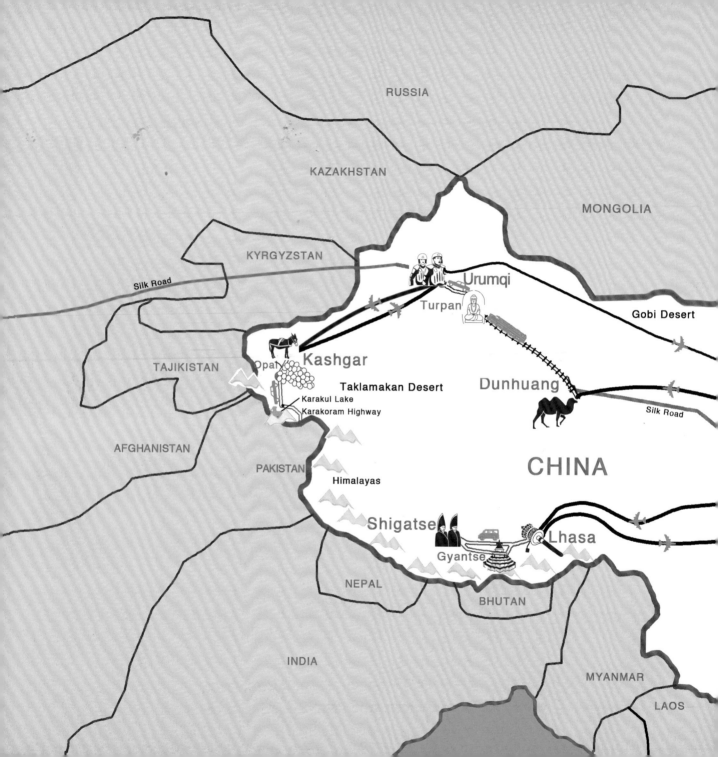

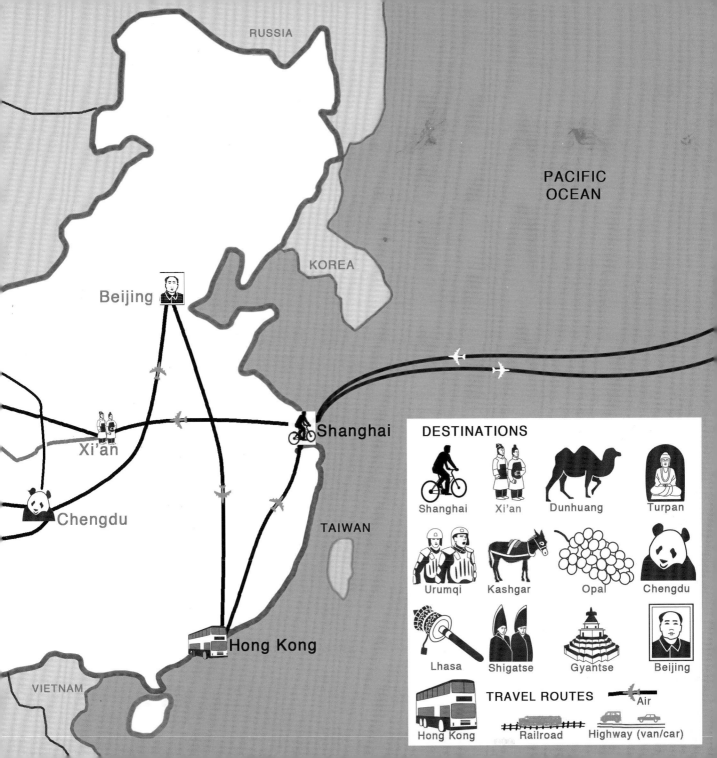

Bullet Trains to Yaks

Glimpses into Art, Politics, and Culture in China and Tibet

STAN BIDERMAN

Photography by Kathryn Minette

IRONY PRESS
www.ironypress.com

Published by: Irony Press
www.ironypress.com

Editor: Ellen Kleiner
Book design and production: Janice St. Marie
Map: Richard Harris
Map icons: Jaye Oliver

Printed and bound in Canada by Friesens

Publisher's Cataloging-in-Publication Data

Bullet trains to yaks : glimpses into art, politics, and culture in China and Tibet / Stan Biderman ; photography by Kathryn Minette. -- Santa Fe, N.M. : Irony Press, c2011.

p. ; cm.

ISBN: 978-0-9832636-0-9
Includes bibliographical references.

 1. Silk Road--Description and travel. 2. China, Northwest--Description and travel. 3. Tibet (China)--Description and travel. 4. Asia, Central--Description and travel. 5. Art, Chinese--China, Northwest. 6. Art, Chinese--China--Shanghai. I. Minette, Kathryn. II. Title.

DS327.8 .B53 2011 2011920533
915.8--dc22 1104

1 3 5 7 9 10 8 6 4 2

*The text is dedicated to my mother, Helen,
for her indefatigable attitude, thirst for culture and travel,
and immense love of family.*

*The photographs of China are dedicated to Kathryn's late father, Maurice,
who inspired her with constant curiosity, a sense of adventure,
and an unquenchable wanderlust.*

Contents

PROLOGUE

My wife Kathryn and I are daunted by the idea of a fourteen-hour plane trip, but because I have accumulated sufficient frequent flyer miles for us to travel business class on American Airlines, the trip from Chicago passes quickly and we arrive in Shanghai to await our turn at customs. We are on our way to witness the Silk Road, Tibet, and wonders in between.

We will have tour guides. Initially, I attempted to schedule this trip myself but soon realized that because of the language barrier it would be difficult. After some research, I contacted a travel agent named Julian, a Chinese expatriate living in Canada whose company arranges tours in China. As we wanted to travel late in the tourist season, Julian offered that if we committed to this journey we could take the tour alone—a perfect compromise. At each destination, we would be met by a local guide who would focus on a suitable itinerary and provide us with cultural and historical information that would add to our enjoyment of the trip and our understanding of China.

We are in search of treasure, both experiential and cultural. Primarily, we hope to add to our contemporary art collection. Our home is filled with cutting-edge works by local Santa Fe artists, along with three smiling ceramic monkey heads we found in New Zealand. Although we both have an interest in contemporary art, Kathryn is an authority who has lived her life focused on visual art, and because of this I often joke that I sleep with my curator. In addition

to looking for contemporary Chinese artwork to place in our home, our quest includes the pursuit of ancient Chinese crafts. We are also in search of stringed instruments, as I have played the guitar for over forty years and am in the habit of seeking out instrument makers during our travels. We consider instrument shops, craft exhibits, and art galleries to be windows into the soul of a culture.

As it turned out, our guides and some locals often questioned the wisdom of following the Silk Road on our initial visit to China, remarking that a more typical and benign itinerary would not include the outposts of Dunhuang, Turpan, and Kashgar, or a jaunt to Tibet. It was my innate curiosity and sense of romance that led us to plan the trip over the Silk Road after Kathryn initially suggested a trip to Turkey. Having seen photos of the animal market in Kashgar, I considered it the destination of my dreams for this journey. My inclination to follow the ancient Silk Road was also predicated on my belief that China was changing rapidly and a decade later the area would be entirely different and more modernized.

In my travels I am compelled by the edges, whether driving to the end of a desert road and finding the rickety three-house hamlet of Candelaria, Texas, 70 miles from the nearest town and a spit across the Río Grande from Mexico; looping Alaska's circle of civilization with my business partner, Abe, after crossing the Yukon, heading northwest from Tok to Fairbanks and then south to Anchorage through Denali; gazing at an imagined European coastline with my literary mentor, Patrick, from the eastern edge of North America in

St. Johns, Newfoundland, where the first transatlantic cable was laid across the ocean floor; or hiking Stewart Island with Kathryn, in search of kiwi birds on our engagement trip south of the South Island of New Zealand, near the bottom of the globe. We head to Kashgar and Tibet with anticipation of similar wonder.

Our decision to follow the Silk Road is more than validated by our experiences. We have, as anticipated, seen much evidence of rapid evolution, such as shaggy yaks grazing near concrete mountain yurts and telephone dishes in the western Taklamakan Desert, as well as reaching the Shanghai airport on a twenty-first-century Maglev, or magnetic levitation bullet train traveling at half the speed of sound. We have also observed street sweepers with archaic brooms manicuring new roads in the Gobi Desert. And though our trip began with no political agenda, we are now converted, having seen widespread oppression expressed both through military intimidation in Tibet and the Xinjiang Autonomous Region and in a Shanghai art scene too impotent to challenge the political beast. We are under no illusion, however, for we realize we have uncovered only the slightest tip of the elephant's trunk.

Our Shanghai Shills and Terracotta Warriors

THURSDAY, OCTOBER 15, 2009 ~ SHANGHAI

Our hotel in Shanghai, the Radisson New World Shanghai, is opposite People's Park and to our liking. We are well treated and soon find out that the staff wants to practice their English. The hotel lobby is an oasis from the mayhem that is Shanghai, but we are enjoying the excitement of being strangers in a strange land.

Though we have come to immerse ourselves in the culture, we begin timidly. We take the elevators to breakfast, where we are overly concerned about cleanliness and quality. At the breakfast buffet, our neighbors eagerly abandon themselves to platters of the unknown, while we order dry sandwiches and coffee. Even though we begin our trip afraid to eat the vegetables for fear

*Mascot for
2010 Shanghai
World Expo*

they have been cleaned in fouled water, as we become more acculturated the food turns into a bedrock of our exploration, as well as recreation.

We are fledglings navigating the streets, and crossings are initially terrorizing. In this city of millions, cars, trucks, bicycles, pedestrians, taxis, busses, and a Maglev train are squeezed together in a constant waterfall of traffic. I learn to immerse us in a herd of street crossers, assuming those on the edges would get thumped first. But the pedestrians are as skilled as any acrobats or daredevils, and we try to imitate their movements to learn the rhythms of city survival.

Shanghai is vibrant, noisy, dusty, and rattling with construction and traffic. We were in a fender bender two days ago in our taxi and saw another yesterday. That's what happens when the roads are loaded with transportation vehicles of every size and shape crammed into 20 percent of the space necessary to support them. We are in a river of traffic, constantly flooded.

We venture through an understreet passage to the pedestrian mall beginning on the next block. The street is relatively quiet during daylight hours, with mere thousands of people; but at night it becomes a phantasmagoria of life, with vendors, hawkers, restaurants, and a neon explosion exceeding the luminal output of Times Square. As hawkers thrust pamphlets at us advertising

unwanted watches, we learn to remain steadfastly offputting and continue our determined stroll, all the while energized with a childlike fascination at the neon.

The young people especially are intrigued by all things American, reflected in their T-shirts and billboards. On People's Square, where we are staying, we are constantly approached by young adults wanting to practice their English.

Last night as we were walking, a group of twenty-three-year-olds—four women and a man visiting from another city for a wedding—stopped us so they would have a chance to speak English. The women told us they were

Thieves and naives, Shanghai

schoolteachers and the man was an engineer. They were dressed like young people in America, and took turns talking and texting on their phones. After a while they asked if we wanted to go to an ancient tea ceremony, for which they had made reservations before coming to Shanghai. We walked through the maze of neon up the stairs of a nondescript building and into a small room set up for tea service. There were seven chairs, exactly the number in our group, and the walls were papered with Chinese characters. Boxes covered with silk lined a bookshelf beside eight glass jars filled with exotic teas of different colors and shapes. Our friends rubbed their hands together to indicate the teas were handmade. The woman leading

the service, wearing a traditional Chinese dress with Mandarin collar and frog closures, had personally prepared the herbs for the teas, said our coterie of twenty-three-year-olds, who proceeded to translate her detailed explanations of this ancient service.

Over a period of about an hour, we each had had six small cups of tea, while the youths spoke English, occasionally looking up a word on their hand-held computers. Two had been English majors in college, and all had taken English in school for nine years. Still, our attempts to recognize certain words were comical; it took about ten tries to understand "Marilyn Monroe." They liked Kathryn's skin and hair, since light skin is considered more beautiful here, and one girl kept touching, almost caressing, Kathryn and asking me if I was jealous. They also said the Chinese like big noses, which put me at an advantage, and they called me "professor." We considered this a strange and lyrical experience until the concierge at the hotel later told us that the young people were paid to bring us to the tea ceremony so we would pay a ridicu-lously exaggerated price to experience it. We had to laugh at our naïveté.

This morning we talked with an American landscape architect from Louisville who works here two weeks a month. The business opportunities in Shanghai are endless, and the chance to talk to a fellow American who lives in China half-time instilled confidence that we are up to the challenges of navigating this unfamiliar culture. Initially fearful, we now believe that we are indeed capable of handling the next five weeks traversing the country.

One of our early destinations is The Bund, the Wall Street of colonial Shanghai, but we taxi there only to find massive construction for the Shanghai 2010 Expo obstructing our view of the bay. Plywood covers the sidewalks, while jackhammers work nearby, and though the city is modern, in a curious anachronism all the scaffolding is bamboo. We are disgruntled, having hoped to immerse ourselves in the architecture and history of this area; instead, we wander a labyrinth of barriers and heavy equipment. This experience is also our initiation into Chinese air quality, as our lungs are being filled with concrete dust and lacquer fumes, simulating the atmosphere of Dante's *Inferno*.

Disappointed in The Bund, we explore the nascent home of contemporary art in the Sino Republic, the art district in Moganshan, a focal point of our trip. Kathryn's taste in contemporary art is both more sophisticated and less representational than mine, but we normally manage to agree on many satisfying and challenging pieces. Kathryn also has superior knowledge and expertise. She recently retired from the position of director of the Art in Public Places program for the State of New Mexico after twelve and a half years of work and has juried art shows and served on the boards of art organizations.

Upon arriving in Moganshan, our street view is of a facade that resembles any reclaimed warehouse art district in the United States. We spend a half day looking through perhaps thirty gallery spaces, and while we appreciate the artists' effort we find most of the offerings gloomy, fatalistic, and unprovocative.

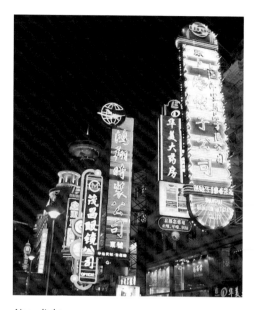

*Neon lights
of Shanghai*

Spontaneity, daring, creativity, and maturity are lacking, in contrast to artwork we have seen in other countries. Certainly irreverence is impossible to find on Moganshan Road, the back alley of a political system based on fear, where challenging the beast is not permitted. We feel for the Chinese artists and are not tempted to make a purchase.

Though we later read that there is a burgeoning contemporary art scene in Beijing, we have learned it is generally associated with government-sponsored exhibitions of works that pose no threat to the authorities. We resolve to instead seek treasure among traditional crafts.

Returning from Moganshan, we venture into the Chinese restaurant at the Radisson, the Mingxuan Noble House, for an early dinner. The elegant restaurant caters to Chinese guests, and we find fine adventure in reading the menu. We have our choice of chicken foot tendon with mustard, pickled sliced pork trotter, cold black fungus, or the "chef's recommendations" of pan-fried fish lips "Shunde style" and two soups—"nourishing soup (invigorating the kidney)" and "nourishing soup (enhances beauty)." Still timorous, we order fried rice and a crab dish and enjoy our initial foray into the wonders of Chinese cooking.

SUNDAY, OCTOBER 18 ~ XI'AN

We arrive at the Xi'an airport late in the evening on Shanghai Airlines flight FM 9207. Xi'an is 1,500 kilometers west of Shanghai, or roughly the distance from Baltimore to Kansas City. Our first official tour guide, Dan, meets us for our transfer to the five-star Sheraton Hotel Xi'an. On the way, Dan explains that Xi'an means "western peace," and we are entering one of the four capitals of ancient China. He also advises us that the typical Han greeting is "Have you eaten?" It must have evolved from a tribe of the lost Mothers of Israel, I muse. We are excited to have reached the eastern terminus of the Silk Road, though its history is not apparent in this city of over eight million people. Populated for seven thousand years because of its fertile farming valley and existence as a trade center, today Xi'an is an industrial and commercial city, and the area is rich in coal and oil. We notice the smog, a cloudy haze over all the large Chinese cities we visit. Our first day on the Silk Road ends early, and we retire eager for our tour of the terracotta warriors tomorrow.

MONDAY, OCTOBER 19 ~ XI'AN

Our buffet breakfast is elaborate, prepared for the many tourists from diverse areas who have come to see the terracotta warriors and other sites of Xi'an. In addition to various stir-fried and steamed vegetable dishes, there is a Japanese counter with breakfast sushi and another area with hard-boiled eggs in broth, tasteless "buns," a white, marshmallow-textured roll, made-to-order

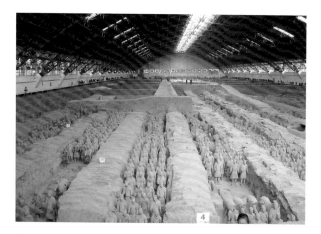

Terracotta archaeological dig

omelets and hash browns, toasts and breads, sugary pastries, sticky rice, and my favorite, fish ball soup, a surprisingly tasty dish. I return for seconds of the soup.

With our guide Dan, who is well-read in English literature and speaks proficient English, we begin to immerse ourselves in Chinese history and culture. Dan, whom we learn is Buddhist, became a guide after teaching school for years and is well suited to his new vocation. According to regulations, Dan has one daughter, who is a student. We begin our tour by visiting the terracotta warriors, a 45-minute drive away.

When we arrive, we are unprepared for the massive scale of this undertaking. The terra-cotta warriors were commissioned over 2,200 years ago by the first emperor of China, Qin Shi Huang, to guard him in the afterlife. Centuries later, farmers digging in a field found fragments of the work, and archaeologists were summoned to excavate, an activity that has been occurring for twenty-five years and remains ongoing today. Pit 1 is covered by an arched roof, like a colossal airplane hanger seemingly mammoth enough to line up three jumbo jets end to end. A sign, captioned "Briefing of Pit 1," states: "Pit 1 is the largest of the three pits. It measures 230 meters long from east to west, 62 meters

wide from north to south, covering an area of 14,260 square meters. Up to now, about 2,000 pottery warriors and horses, 20 wooden chariots have been unearthed within an area of 4,000 square meters. It's assumed that more than 6,000 terracotta warriors and horses, 50 chariots were buried in Pit 1."

In Pit 1, I count life-size warriors ten rows across in military formations. Some are headless, while others are followed by horses. The horses' lips are open, curled, and intended for bridles. In one trough, I count nearly eighty men, many meticulously pieced together from fragments like a jigsaw puzzle. They wear clay overcoats, knee-length trousers, and knee-high boots. Interestingly, their hands are formed to hold spears or bows, but any wooden weapons have decayed. As we walk to the back of the hangar, we see several fragments of warriors being restored. For many archaeologists, this site is like the Holy Grail.

Headless terracotta officers

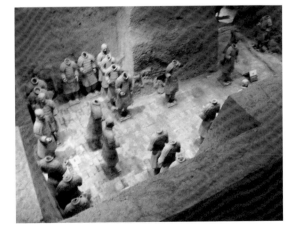

Visiting a deeper pit, we observe kneeling and standing archers and, down a ramp, horses facing upward, along with chariots. This pit is better preserved than Pit 1 and the warriors more dramatic. Some excavated figures are displayed behind glass, and their surviving detail astounds us. We see a general in an armored tunic and the emperor's bronze-domed square carriage,

its four sides representing the earth and the roof the heavens, with four stalwart horses.

Our next destination is the Wild Goose Pagoda, the main Buddhist temple in Xi'an, built in the 600s, damaged by earthquake and erosion, and rebuilt a number of times. The pagoda, seven stories high and leaning, is at the center of the grounds, with a bell tower on one side to greet the morning and a drum tower on the opposite side to greet the evening. Sanctuaries here, as elsewhere, are replete with Buddhist imagery, one an intricate woodcarving of the history of the Buddha covering three walls of a medium-size building and another an elaborate jade mural depicting the stages of Buddha's enlightenment. A smaller chapel is dominated by a large gilded Buddha with blue hair. We notice crumbling tombstones of deceased monks in the garden area. During the Cultural Revolution under Mao, many of the temple's artifacts were irreparably damaged; otherwise the site, previously a target of religious and ethnic cleansing, has since been painstakingly restored and is now regarded as a national treasure.

Monks' tombs, Wild Goose Pagoda, Xi'an

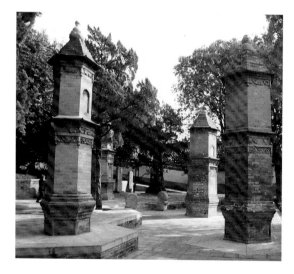

We make a quick tour of the Xi'an city wall encircling the old city. It was built of rammed earth to a height of forty feet and is eight miles long. The top of the wall, now used by

bicycle riders, is wide enough to drive a herd of sheep through and surrounded by an arid moat. There are regularly spaced ramparts from which archers could take aim and watchtowers every few hundred yards. Benches now appear along the wall so that locals can take a respite from the crowds of Xi'an.

After about an hour at the wall, anticipating that the Great Wall will dwarf this one, we head to the Xi'an airport to board an early-afternoon flight to Dunhuang on China Southern Airlines, CZ 6896. We fly west for two hours between jagged snow-covered peaks. The man seated next to us by the window seems to have never been on a plane. I reach for the airline book, find a world map, and point generally to New Mexico. I learn he is from Urumqi, which he

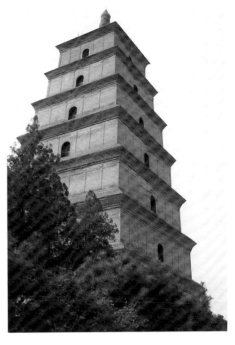

Wild Goose Pagoda, Xi'an

eagerly fingers on the map. Kathryn, seeing him fumble with the box of food the airline provides, shows him how to open it. Our primitive communication consists of pointing and smiling, and though we share no words our warmth and mutual curiosity is clear. At one point he gestures toward the snow-covered mountains outside, wanting us to join in his excitement at seeing them, perhaps for the first time. Later, he quietly gazes out the window and sings a beautiful song to himself. We are mesmerized and feel we are receiving a gift.

Our curiosity is piqued as we reach the outpost of Dunhuang, an isolated town of 175,000 people in the Gobi Desert, just south of Mongolia. It reminds us of the Wild West in some strange way. And it's hard not to be having fun when the sign in our Dunhuang hotel says: "Please Luck the Door."

The Gobi Desert, Donkey Cold Cuts, and the Silk Road

TUESDAY, OCTOBER 20 ~ DUNHUANG

We are at the edge of the Gobi Desert in Dunhuang, which has roots on the Silk Road as far back as two thousand years ago, when it served as a military base protecting caravans on this ancient trade route. Although Xi'an was the Silk Road's eastern edge, over time it lost any quaintness and sense of history due to its size, so it is no surprise that we are only now feeling the romance of the Silk Road.

After we check into our hotel, Ri, our guide, immediately takes us to the Dunhuang Museum for our orientation. The museum seems like a very old university lab with wooden display cases and ancient relics unprotected from sun, dust, and in some cases, human touch. A museum in the West coveting these

items would present them in controlled air and light displays. Ri, or Arthur as we call him, wants to be our friend. His English is proper, though a bit stilted, staccato, and tinged with the local Chinese dialect. It is also punctuated with laughter, perhaps from nervousness. We have some trouble understanding him. I take the lead since, having grown up in an immigrant family, I am a good interpreter of broken English. Arthur repeatedly tells us that Dunhuang is a "very beautiful town." He also delights in showing us a photo of his young son on his cell phone. As his wife, whom he first met at a party, works at the electric company, his baby remains in the care of his parents on their small farm during workdays. He is clearly proud of his home, his family, and gracious in introducing us to his corner of the world. Accustomed to people in their fifties being more sedentary, Arthur can't believe that Kathryn wants to ride a camel.

We walk through the market, where the vegetables look fresh and delicious, and the meat not hanging from hooks soaks in vats. Live chickens and rabbits are for sale; chunks of pork are being stewed; and a vendor with an ancient cleaver chops lamb from a carcass to a buyer's order. Dogs are present, but they must be well fed because they aren't begging, and flies are surprisingly nonexistent.

We have not seen other Caucasians since arriving in Dunhuang. In fact, the people here all seem to be Han, the main ethnic group of China, though to us they look larger. After our introduction to the Han of Shanghai and Xi'an, we are surprised that Arthur stands over six feet tall.

Tonight at a local restaurant we eat donkey sliced thin, served cold, and dipped in chili oil. We find this delicacy pretty good, though a bit chewy. Afterward, Kathryn jokes that she is both burping and braying. As providence would have it, on our walk home from the restaurant we pass a man leading a donkey cart, our meal now on hoof before our eyes.

Later, as we prepare for sleep on a mattress reminiscent of particleboard covered in a 15-thread-count sheet and an itchy wisp of a cotton comforter, I read to Kathryn from "The Manifesto of the Dunhuang Hotels State Owned" service directory, which states, in part: "Welcome to Dunhuang Hotel. If you would like too take one of the room articles or if you accidentally mangle it, please not the following list of costs…Upon registration, the guests are requested to show their certificates, and explain the accommodation reason…The guest should obey the hotel regulations and cherish the public property…. You can not use the broad bank to do anything harmful to the country safety and secret. Moreover, checking, copying, and spreading any blue information are strictly prohibited…Sending baleful documents and advertisements are forbidden…Inflammable, explosive, poisonous and radioactive items are not allow-ed inside the hotel…Bustup, gambling, freak-out wench and drink are strictly prohibited in the hotel…Dunhuang Hotel reserves the right to explain the details of the Guidance."

Due to some minor discomfort in the middle of the night, I began to think the donkey was kicking back. But this morning he remains domesticated.

Many nights when I scroll the television looking for CNN, I am restricted to local offerings. There is a rhythm to the stations. One broadcasts the dry party line with rows of illegitimate dignitaries listening intently to interminable speeches. Another airs Chinese opera. A historical war movie seemingly reflects an obsession with regalia, machismo, and hostilities. Yet another channel focuses on sports, such as volleyball, basketball, and hurdling. Finally, and my least favorite, providing a sense of levity in a culture dominated by a bleak regime, there are comedies with goofy actors wearing ridiculous costumes and telling childish jokes, reminiscent of Jerry Lewis and Soupy Sales. The programs are unsophisticated and lack the depth of those in cultures allowed to struggle openly with their internal differences. Here it is as if the viewers are being conditioned and treated like children.

A highlight of our time in Dunhuang is a visit to the Mogao Grottoes, listed as a World Heritage Site in 1987. As we drive across the desert toward the grottoes, we see a strange scene in the distance. No sooner does Arthur realize that a movie is being filmed than we drive through a horde of samurais riding horses.

Because of its strategic location, Dunhuang was a prosperous city for hundreds of years, and as Buddhism grew, the fortunes of Dunhuang led to the building of the Mogao Grottoes, also known as the Thousand Buddha Caves. Construction began in AD 366 and continued for close to a thousand years, finally resulting in 735 caves of various sizes and shapes carved into

the hillside, according to the postcard we are given, or 492 according to our itinerary. The caves were originally built to store Buddhist manuscripts; then later generations painted murals and carved colorful Rushmore-size giant Buddhas and other religious icons from the mountain. It is said that in many of the caves "one thousand Buddhas" are painted on the walls and ceilings; after seeing a number of the caves, I inquire if there really are one thousand and am told it is a figure of speech used to describe the voluminous number of paintings. The Buddhas, while numerous, are not identical, and some have had their eyes scratched out by Muslim raiders who considered them impotent without their sight. In

Mogao Grottoes, Dunhuang

the early 1900s, the British Museum and the Louvre purchased several manuscripts and paintings that the Chinese government now wants returned, believing that the items were procured in cave raids conducted by personnel from European museums and other profiteers.

This part of the Silk Road is an agricultural oasis, and we marvel at the vegetables, which are large, well formed, and enticing. Based on local evidence, the flavor, quality, and appearance of vegetables fertilized with animal and human manure surpass those industrially grown by machines. Left and

right, the spits and valleys of farming checker outskirts and countryside, and the abundant produce in local markets is indicative of their efforts.

WEDNESDAY, OCTOBER 21 ~ DUNHUANG–TURPAN

This morning we head to the Singing Sand Dunes and Crescent Moon Lake. Kathryn has pledged to ride a camel, and I go along. We arrive at the camel yard, where there are hundreds of dromedaries with elaborately decorated saddles and fascinating faces. We select a long ride to the top of the dunes and rent orange booties that go over our shoes to keep the sand out. Kathryn comments that our foot garb looks as if we will be wading through nuclear waste. But thankfully our feet are not even encumbered by camel dung, which is promptly secreted and used for fertilizer or insulation.

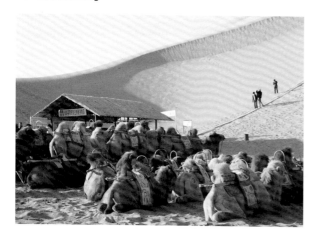

Singing Sand Dunes, Dunhuang

The camels kneel upon the command of their master, and we climb aboard crude wooden and cushioned saddles. As the camels rise, we jolt a bit but are soon on our way. We begin our lumbering clomp–clomp–clomp up the dunes with other riders in the distance, imagining what it felt like to be part of a caravan long ago. The camels are tied single file and connected by ropes through a plug

in their noses. Kathryn notes that, partly hidden behind their baggy lips, some of the beasts have brown teeth which look like worn and broken piano keys and that their language seems limited to a baritone squeal. I find riding them more comfortable and more interesting than riding horses or mules. Kathryn is momentarily chagrined at the manner in which one herder is treating his camels, but far be it for me to explain political correctness to a Uighur camel herder in the Gobi.

We go as high on the dunes as the camels are allowed, then walk the remaining way up the shifting sands to the top, balancing ourselves while slipping, sometimes helped by wooden planks hammered into the sand as steps. At the top, we witness a breathtaking vista of endless dunes in cool morning sunlight, and then gleefully scoot down on a primitive wooden sled to the bottom.

Next, we mount our long-necked ruminants for a ride to Crescent Moon Lake, 5 kilometers to the south of Dunhuang. Our entry ticket says: "The sand-dunes and lake are put together by nature since the ancient time, and until today it is also celebrated for the wonder of Go-bi desert. The sand dunes extends [sic] more than 40km from east to west, and 20km from north to south. It's [sic] famed for the moving sands echoes, and thesand [sic] dunes embraces a lake in shape of a half moon. The scenic spot is listed as the major scenery by the state council in 1994."

At the lake there is a pagoda, but we elect not to walk there upon the advice of Arthur, who says we won't be allowed inside. The lake is crescent shaped and,

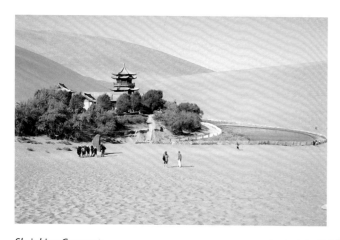

Shrinking Crescent Moon Lake, Dunhuang

unfortunately, shrinking, with only one type of fish, which we are unfortunately unable to see. We walk back to our camels for the return trip to the stables, where Kathryn and I spend thirty minutes lost in the sea of these captivating beasts of burden.

Late in the afternoon we head to the train station, which is an hour away, for transport to Turpan, our next destination. We start over a dusty neighborhood road, and at one location our driver stops the car and runs into a house, returning with a large carton of grapes; apparently it is the home of a relative. We arrive at the crowded station around 9:00 p.m., and since our train doesn't pull in until 10:30 p.m. we have time to reflect on how this small village seems to have grown up around the station, with whistle stops determining the fortunes of many hamlets and trading posts across the Gobi Desert.

We pass through security and are seated in a room. Every fifteen minutes a uniformed guard walks through the room and harasses everyone stretched out on benches, as regulations require us all to sit up—an edict that is immediately ignored as the bumptious guard leaves the station room. The predominantly Uighur passengers travel with boxes and suitcases of undetermined contents;

but grapes seem to be everywhere. A Uighur woman stares at Kathryn, who soon starts to show her, and an expanding group of the curious, our photos. Finally, Arthur leads us to the platform where we board the train and enter our private compartment.

We have paid for all four berths at a cost of an additional US $90 to assure our privacy and comfort. There are some pillows and blankets, although it is unclear when they have last been cleaned, and a washroom near our room with three sinks that are foul. A Western toilet next door with a broken wooden seat is worse. This is an effective but unromantic means of travel. Kathryn hands me an Ambien, and we prepare to sleep in our clothing. We are awakened at 5:00 a.m. as we arrive in Turpan.

Our new guide, Lilly, meets us. Initially we find her humorless, but as we get to know her we like her more and more. We are saddened that somehow a combination of Communist indoctrination, working in a society where men have dominated for eons, and having parents who followed the party line has made this twenty-nine-year-old cynical, bleak, and a bit life-worn. We learn Lilly likes to read books in English and is having trouble finding a "nice man." She is overly serious though professionally capable and knowledgeable, as are all guides in China, where being a guide is a profession. All guides are indoctrinated in the party line and tend not to stray from the authorized dogma.

We are driven to our hotel, the Turpan Jiaohe Hotel, passing the street sweepers at dawn with their crude brooms. Upon arrival it becomes clear we

are the only guests at this walled compound. We all, including Lilly and the driver, retire to our rooms for a few more hours of sleep. Soon we are awakened and go to a room built for one hundred and fifty for a breakfast of eggs, toast, and two kinds of processed breakfast sausages, pink and unsettling.

THURSDAY, OCTOBER 22 ~ TURPAN–URUMQI

After breakfast we travel to the Jiaohe (Yarkhoto) Ruins, an ancient garrison town destroyed by the Mongols under the leadership of Genghis Khan, which is situated on a bluff between two branches of a river. We learn that we are in the Turpan Depression, the floor of the Gobi Desert, 328 feet below sea level and the lowest place in China—also the hottest in the summer and brutally cold in winter.

The ruins, some 2,300 years old, sit atop a plateau, the steep banks to the river a natural obstacle to marauders. The adobe ruins are about one-quarter mile wide and seem to go on for over a mile; Lilly says as many as seven thousand people are thought to have lived here before the Mongol invasion. It is an eerie and remote site, evoking Chaco Canyon, an abandoned Pueblo fortress in the American Southwest. Though the earthen Buddha heads of the decaying temple have weathered, we learn the Jiaohe may be one of the best-preserved mud cities in the world, due to the arid climate and inhospitable and inaccessible location. In addition to the temple, we explore an ancient well and the remains of a prosperous family's home, with a prime

view overlooking the river. On the opposite side of the river, we see wooden box-shaped structures; Lilly explains that these primitive constructions are for drying grapes.

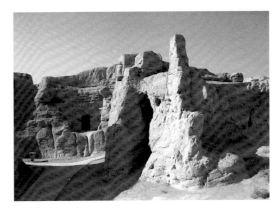

Ancient mud city, Turpan

We leave Jiaohe and head to the Bezeklik Thousand Buddha Caves in the Flaming Mountains, where, according to legend, a monkey king burned his behind on the mountaintop. Some maps position this place in the Gobi Desert; while on others the western Gobi is a separate desert, the Taklamakan Desert, which extends west past Kashgar and abuts the Pamir Mountains bordering Kyrgyzstan and Tajikistan. The caves are located between barren hills above a small green river valley and are painted with murals of Uighur princes, princesses, and Buddhist monks. Many caves unfortunately were pillaged by European explorers in the early twentieth century, although the ceilings remain adorned with paintings of the thousand Buddhas.

My personal highlight of the caves is an ancient Uighur man I see seated on a blue plastic chair against a rail overlooking the solitary green spit of valley, his amber skin parsed between his deep red and white skullcap and the triangular wedge of hair hanging below his chin. He plays a stringed instrument, and though Lilly prods us to see the ancient cultural artifacts, I am enamored of the present. Initially he hands me a tambourine; a few moments

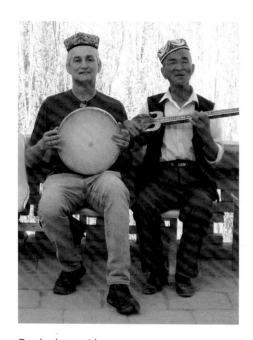

Troubadours with rewap and drum, Turpan

later he becomes my teacher as he takes the tambourine, places his intricately carved lute in the crook of my arm, hands me a plenum, and invites me to play. Accepting his invitation, I begin to understand the secrets of this mysterious seven-stringed Asian instrument, which I later discover is called a rewap. Our maestro soon adorns us with skullcaps, and for a small price we take photos with our smiling troubadour as Kathryn poses like an Egyptian, one arm upturned and one down.

We leave the area and follow the road to Urumqi, the largest city in the autonomous region and the site of recent riots. Our driver speaks to Lilly in a demeaning manner, though we do not know why, and mumbles incoherently under his breath at the crush of traffic as we enter the city, honking incessantly and affecting nothing. We have lunch at a Uighur restaurant, and in the late afternoon head to the airport for our flight to Kashgar via China Southern Airlines, CZ 6805. It is Friday, and we will meet up with Lilly again on Monday after our much-anticipated pilgrimage to this medieval city.

guide there explains that its features are not Han, but European. Looking at the mummy, down to the detail of her eyelashes, my assumptions about history and migration are challenged, as I have trouble assimilating how this person arrived in China four thousand years ago. Later, we are told the Uighurs may have migrated from Siberia to Turkey before settling in what is now western China. We are told that *hyuk* in Uighur means "No! I don't want it," a very useful term, especially when being accosted by hawkers. Could it be the origin of our word *yuck*, I wonder, amused at the possibility. Also regarding tribal distinctions, our driver identifies the Tajiks and the Uzbeks by their hats and gold teeth.

Breakfast Saturday morning consists of stewed cabbages, bok choy, white bread, a hard-boiled egg, and a full pot of coffee that is set on the table without a warmer. At the Kashgar Chini Bagh, or Quinibagh Hotel, we eat with a fellow traveler, Mark, who is from Davis, California, like me trained as a lawyer, and, we discover, in the midst of a divorce. I am impressed by Mark's self-reliance in traveling to Kashgar alone. He is nursing a turista stomach, and we offer our remedies, which I am only days from needing myself. My heritage is a big part of my life, and I suspect he is likewise Semitic. On the elevator I gather the courage to inquire, "Vee go to da Shul?" to see whether he understands, and he does.

We are constantly struggling with hygiene. Our hotel in Kashgar, despite being a three-star lodging, is almost like a war-torn ruin, though two unsmiling women assiduously mop the lobby floor each morning, and

the threadbare elevator rug is changed daily and lettered with the current day of the week. When I take the one working elevator downstairs and walk to a small shop in the back of the hotel to buy water or Sprite, I pass the garbage dumpsters, where more garbage lies outside than inside the over-flowing containers. Behind the dumpsters is a fence with painted boards illustrating the new five-star hotel planned for the site—I am dubious and look forward to our five-star hotel in Urumqi. Kathryn has brought an array of goods about which I teased her during the months spent researching online but now treasure: a battery-operated clock/flashlight; a thin pair of slippers, consisting of a rubber sole and a mesh toe holder, which protect us from the room floors; WC packets with toilet paper, a moistened wipe, and a toilet seat cover (as most of the toilets are Eastern, we often use the seat covers as additional toilet paper); Pepto-Bismol, which has replaced vitamins in my diet, and Imodium, which replaces the Pepto-Bismol on numerous occasions.

Furthermore, we are never given sufficient napkins at meals. Often only about six very small thin napkins, or sometimes Kleenexes, are placed on the table, which we use sparingly, stuffing any leftover ones in our pockets for future use. In our three-star hotels, we are supplied with half rolls of toilet paper plus whatever is left from the previous guest, but it is never enough.

After breakfast on Saturday we head to Karakul Lake, 200 kilometers south-west of Kashgar, 60 kilometers from Tajikistan, and about 100 kilometers from

Pakistan via the Karakoram Highway, an ancient trade route going back at least two thousand years. In fact, Marco Polo is said to have stayed at long-withered inns along this road. The Karakoram Highway, considered the world's highest international road, is the westernmost passage over the Himalayas, an engineering feat stretching 800 miles from Kashgar to Islamabad.

Our first stop is Opal, a roadside village bisected by the two-lane highway. Our guide, Aashif, shares that the first Uighur dictionary originated in this ham-

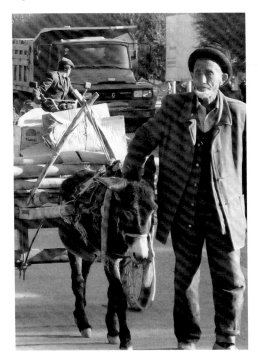

Uighur traffic, Opal

let. Aashif gets out to buy melons and fresh loaves of bread and invites us to take a fifteen-minute break to explore the roadside mélange. Watermelons, oblong orange melons, and tan and orange gourds sit in piles and on tables. The Uighur vendors take a melon from the mound, cut it with a small machete, and offer us slices. We refuse their offerings as we don't know what the commitment may be if we accept, and continue down the road. Though we see none during our visit, I surprisingly learn on our return home that oranges originated in China.

Later, we see bread being baked outdoors in a round oven similar to a tandoor. We watch as a woman kneads the dough on a crude table and a man with a wooden paddle turns the round loaves

and stacks them at his roadside bakery. The
loaves, which look and smell delicious, are
about 15 inches in diameter, golden brown, and
sprinkled with onions.

I am also intrigued by the animal carcasses
we see hanging overhead. On the ground
under one butcher's table is a sheep's head
looking contentedly at me. Initially, I do not
comprehend that the head has been severed,
as it rests on three legs in a pastoral pose, but soon realize that the white sack
with red capillaries to its left is its stomach and the third element of the hori-
zontal display is its shorn fleece. Once again I am surprised at the lack of flies,
and am pleased to see honeybees circling the fruit.

There is a constant procession of donkey carts through town, carrying
people and cargo. We take photos of two festively dressed women—wearing,
among other garments, bright head scarves, colorful striped socks, and high-
heeled shoes—at the helm of a two-wheeled donkey cart carrying three live
sheep on the platform behind, as well as two children, one on a lap, the other
bundled. They watch us as we watch them, and smile as Kathryn takes their
photo. In this area we also constantly see three-wheeled motorized vehicles
with small platforms behind, taxis carrying cotton bales, hundreds of three-foot
strands of garlic, bushels of onions, coveys of green vegetables, passengers,

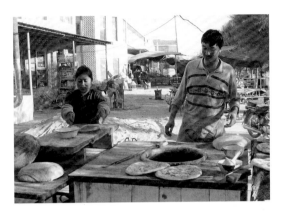

*Roadside bread
bakers, Opal*

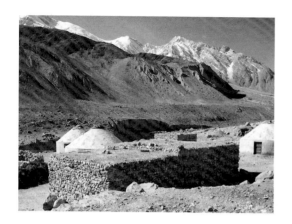

Kyrgyz outpost in the shadow of the Pamir Mountains

sheep, bricks, or coal. When we return to our car, we find Aashif and the driver at vendors' stands, purchasing melon slices to share, the driver buying loaves of bread and red grapes for us. We leave Opal happily sampling the local food offerings.

As we climb up the river valley, we see small herds of camels and yaks in the care of their masters. The terrain becomes increasingly inhospitable and monotone; only in the river valley are there plants, while the mountainsides are barren, nearly indistinguishable from a lunar landscape, though the natural landscape is disrupted by the debris of mining practices. Kathryn says the mountaintops look like arrowheads. We pass through cabal checkpoints, with which I have no problem as we are a stone's throw from Tajikistan, Kyrgyzstan, and Afghanistan.

We arrive at a tiny Kyrgyz outpost, and the driver pulls over. We cross a rickety bridge high above a rushing river riddled with boulders; the steel cables appear substantial enough, but the irregular planks extending the 150 feet or so above the gorge are unnerving, and the bridge starts to sway from our steps. We are stunned to learn that this trapeze also serves the Kyrgyzs' livestock—yaks, sheep, lambs, maybe even camels—which return from higher mountains as winter approaches.

On the other side, a Kyrgyz woman has goods for sale on a rock table. Initially they appear to be the standard baubles and beads, but Kathryn, with her eye for the unusual, spots some interesting small carvings—primitive yaks whittled from yak horn, replete with horns of rusty iron and tails of yak hair. We negotiate a price, as expected, and ultimately buy the carvings for a pittance. The Kyrgyz woman becomes interested in Kathryn's turquoise earrings, but we are not willing to give them up.

The woman, her face enveloped in a gold scarf, invites us into her home, similar to a yurt but built of rock and adorned with blankets and colorful textiles. Her features are both exotic and weather-beaten, belying her thirty years by at least ten more. In the low-ceilinged first room we immediately notice a sheep carcass hanging at eye level. A curtain separates this room, which must be the kitchen, from the inner room. To our surprise, a baby, about one year old, sleeps in a sling hung from the ceiling, wearing a blue shirt and soft-soled shoes that slip out from the ends of a blanket; two red straps secure him in his perch. The family bed is atop an oven of raised brick, where a fire can be built to warm the family in winter. The woman invites us to eat, but Aashif advises us to turn down this invitation as the woman

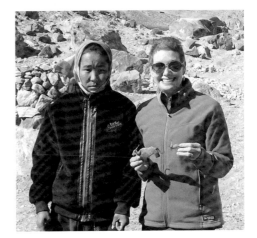

Our Kyrgyz friend and her yak carvings

will then want to sell us the blankets off her walls. Reluctantly, we leave this spellbinding glimpse into a faraway dream, but I get tears in my eyes when the Kyrgyz woman hurries to Kathryn as she begins walking on the bridge, wraps her arm around Kathryn's waist, and while staring devoutly at her red hair and turquoise earrings, secures her crossing of the river below.

After returning to our car and resuming our climb, we reach an irregular plateau that looks like a glacial plain, sprinkled with occasional camels and yaks, their fur resembling scraggly dreadlocks. We are astonished as the driver calls our attention to a huge bird on the ground, the largest and most feathery eagle I've ever seen. In the instant it takes Kathryn to pull out her camera, the eagle becomes suspicious, takes off, and frustrates our desire for continued observance. Once home, I research and find this is a golden eagle, *Aquila chrysaetos daphanea*, which ranges from southern Kazakhstan east to Manchuria and southwest to China.

At last we reach Karakul Lake, which lies almost twelve thousand feet above sea level in the laps of Muztagh Ata and Kongur, two of the towering peaks of the Pamir Mountains. Muztagh Ata, at 24,757 feet, is the forty-third highest mountain on earth. Though Karakul means "black lake," we find its color much more of an azure blue. We are now 60 kilometers from Tajikistan, though a jagged maze of peaks for 250 miles separates us from its capitol, Dushanbe. Lunch is served at a restaurant with a panoramic view, which was built by a hotel chain from Beijing. After lunch we stroll on the primitive

boardwalk, and two white long-haired puppies, with upturned and curled tails, perhaps four months old, frolic, seeming to have the times of their lives nipping at our heels. We see four or five yurts across the lake, and although Kathryn wishes for a clear look at the mountaintops to record the view, it is not realized, but the beauty of the nearby scenery offers abundant opportunities for good photos.

Yet for all the beauty of this place—the lake, mountains, and yurts—our most enduring memory may be the open waist-high, concrete-block, outdoor latrines for men and women. As I enter, the slats are spread about eighteen inches apart, engineered just wide enough to squat above the trench below; obviously many have preceded us, as I am greeted by a cone-shaped mound of pungent evidence. Later, Kathryn is shown a newer WC, but upon entering she discovers that while the exterior may have changed, Marco Polo would still recognize the plumbing.

On our return down the mountain, we stop to pass time at a checkpoint. Along the side of the road, a woman weaves on a crude loom in front of a tiny outdoor shop selling baubles and drinks. Though she sits on the pavement, she is nicely dressed in plum and white garb, with white flowers embroidered on her scarf, and purple and white gloves. Fortunately, she wears thick tights as the position of the loom requires a revealing posture. Kathryn and I meander farther down the roadside, where we notice a solar panel directing the sun's rays to a 12-volt car battery, which we assume is a daily practice to store energy.

SUNDAY, OCTOBER 25 ~ KASHGAR

Our expectations are at a peak in anticipation of the Sunday market in Kashgar, which, according to our itinerary, is "as exotic to the average Han Chinese as to the foreign tourist." We are told this is one of the most ancient markets in the world, and our itinerary indicates Kashgar is an "essentially medieval city." We are starting late as this westernmost city in China officially operates on Beijing time although over 2,000 kilometers away, so it doesn't get fully light until after 9:00 a.m.; locals, in a minor act of defiance, sometimes set their clocks two hours earlier to avoid inconveniences. To my chagrin, instead of first going to the animal market, my raison d'être in Kashgar, we head for the Apak Hoja Mazar, more lyrically known as the Fragrant Concubine's Tomb. The mosque on the grounds of the Mazar, especially with its ornately carved and painted pillars and ceilings, soon charms us. Photo opportunities for tourists are offered by a young man with a camel and at a booth where women can pose as the fragrant concubine wearing an appropriate costume. Kathryn demurs.

The Fragrant Concubine's Tomb is an imposing and graceful structure built in 1640 in the Uighur style. Its exterior is of blue, green, and yellow iridescent tiles, like shimmering squares of alligator skin, with minarets at each corner and a large dome in the center. Earthquakes have periodically damaged the structure, resulting in handfuls of square tiles loose or missing in places. Seventy-two Hoja were buried here—the first being Yusuf Hoja, whose reputation was eclipsed by that of his son, the revered missionary Apak Hoja. Here there is a

pecking order even in death: the tomb of Yusuf is overshadowed by that of his son, while those of the rest of the family are located off to the sides. The Fragrant Concubine's Tomb is named for a woman of outstanding beauty whose scent attracted butterflies that constantly encircled her. There are many legends surrounding this mysterious woman. Aashif tells us that her family was killed and then she was taken to Beijing as a concubine for the Qing Dynasty's Emperor Qianlong. Others say the emperor had her family put to death so he might take her, or that one of the emperor's generals had her sent to Beijing as a gift for the emperor. Various legends relate that after death her body was transported back to the Apak Hoja Mazar to be buried or, alternately, since such a trip would last three years, that the sand from her burial site was instead transported back to Kashgar. In homage to the legends, we are greeted at both entrance and exit by women wearing and selling butterfly necklaces and hair ornaments.

Tombs adjacent to the Apak Hoja Mazar, Kashgar

As we finally head toward the animal market, we notice stark differences between the Uighurs and the Han, with the Uighurs appearing Arabic and having more in common culturally with the Kyrgyz, the Kazaks, and the Tajiks than with the Han Chinese. We are not yet adept at distinguishing features of the Han, who appear to have striking similarities in hair and coloring, though we

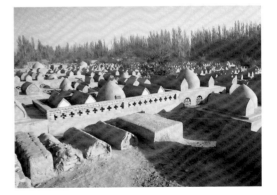

are aware that a year spent living among them would refine our perceptions. Periodically, ongoing ethnic and cultural differences between the Uighurs and Han Chinese have resulted in conflicts. I have read reports that thousands of Uighurs have been executed in this area on the eastern side of the steep mountains, long a major stopping place on the Silk Road. And we know of the riots on July 5, 2009, only three months past, during which 197 Uighur and Han people were reportedly killed in a clash in nearby Urumqi.

Our driver drops us outside the gates of the animal market, where the menagerie overflows with Uighurs herding camels, goats, sheep, yaks, horses, donkeys, cattle, and one angry, massive, hooded bull. Modes of transportation include horse-, donkey-, and yak-drawn carts; motorized three-wheeled vehicles; flatbed trucks; and double-decker livestock trailers. Once inside, we are in a large dusty field, perhaps two or more acres, where livestock are grouped by type. A brick wall surrounds the perimeter of the compound, and I am amused that in this ancient venue a satellite dish crops up like a metallic sunflower. Vendors line three sides of the compound; on the two sides perpendicular to our entry are food vendors, and on the side linking the gates are harness and tack artisans.

We begin by observing the food vendors, especially a Uighur man dressed in white, wearing a squared-off skullcap and black moustache and stirring a vat of vegetables with a large paddle. Scattered among the food vendors, on rough-hewn wooden tables, are platters of diced tomatoes, onions, and

greens. Tin teapots, functional but worn with creases and dents, line the tables. Nine fresh lamb carcasses hang from metal rods at the top of a three-inch pipe frame, likely for consumption in the ensuing hours. A well-used hatchet rests on a three-foot tree stump in front of the carcasses, presumably a platform for the stubborn cuts. Plumes of wood and coal smoke ascend from outdoor eateries.

Soon we are distracted by the cacophony of bleating, braying, hee-hawing, mooing, and bargaining. We are also intrigued by the action of the animals and their owners: cattle owners coaxing their cattle to jump down from truck beds; goats facing each other in rows and controlled by having their faces pushed together and horns locked; the exotic features and black fur conical hats of the Uighur people; a herder tending sixty white sheep, half of them muddied by a market puddle; a single black sheep accenting a herd of brown and white ones; a donkey digging for a phantom scrap of sod, while two of his fettered sisters eat hay from the wagon of their mooring; a young boy tending the rope of a camel going nowhere; tethered bulls pulling at their stakes without success; and prospective buyers warily surveying prospective purchases, inspecting teeth, squeezing testicles, and adamantly bargaining to complete their transactions.

Black sheep, Kashgar animal market

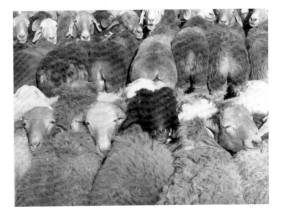

As we wander down one side of the market, I notice a donkey carcass hanging from the planks of an outdoor restaurant, next to a cauldron bubbling with donkey stew, and Uighurs squatting on their haunches eating from crude metal bowls. Piles of coal are strewn indiscriminately around the lot and used for cooking. We walk over to the harness makers, and I am tempted to take a harness home merely for the ornate craftsmanship and colorful decoration. Our attention also is drawn to two men sharpening a knife, their young sons haunched intently in apprenticeship. One continuously pulls a long rubber belt while spinning the whetstone as the second sharpens the knife. Surrounding them are hand-carved sheaths, handles,

Animal market traders, Kashgar

blades, and daggers that look like they could have belonged to the peasant soldiers of Ali Baba or Suleiman. Finally, we watch the exodus of people with their bounty, especially enamored of a short Uighur gentleman with a tall black conical hat trimmed in brown nobly leading his adolescent camel from the grounds. Soon we too exit through a river of flesh and fur, and head to our lunch destination.

Once in the restaurant, we are seated in an area separate from Aashif and the driver, and see exciting dishes passing left and right. Unfortunately,

Aashif's tour company has ordered a meager offering of rice with a few pieces of fatty meat and a couple of wispy lamb chops. I am hungry and therefore temporarily disheartened. But soon I become engrossed in the songs of two musicians on a small stage in the center of the restaurant and walk over to watch how their Uighur instruments are played. The musicians, recognizing my genuine interest, demonstrate the appropriate playing methods, for which I am grateful, as I am thinking of purchasing these types of instruments later to take home.

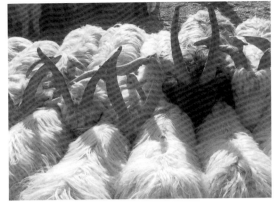

Facing a sale, Kashgar animal market

After lunch our driver drops us at an entrance to the Sunday market, which had been combined with the animal market until a few years ago, when chaos overwhelmed the space and the animal market was relocated to its current venue. Inside the Sunday market we pass vendors gathered in informal groups according to their wares; we next cross into the garlic market, where we see strands of garlic on carts and shoulders. There are hundreds of colorful hopsacks laden with red chilies, trays and tubs of assorted nuts, bolts, washers, and wire with no discernable arrangement. In an alley to our right, we see a primitive open-air barbershop; I shudder at the thought of the barber's straight razor at my throat, though customers on rickety wooden chairs seem undaunted by the razors poised over the curves

of their throats. I notice two patrons wearing red smocks and wonder if their choice of color is deliberate.

We turn right and enter the shoe market, where anarchy reigns. Black men's shoes and athletic shoes—some old, some new—are placed in piles of hundreds; I assume it is up to the purchaser to match a pair. Next we enter an immense covered market to look for raw silks and warm hats. We pass stalls of unfamiliar and intriguing spices, in shades of orange, yellow, tan, and brown; I want to know what each of them is but also appreciate them as a still life rather than a culinary experience. In another grouping there are fifty different brown cloth bags of mixed bouquet teas. A bounty of dried fruits and nuts fill another stall, including raisins, apricots, walnuts, almonds, a local red dried fruit I am given to taste and don't care for. In another cluster, we find medicinal supplies in glass jars, including dried frogs, lizards, snakes, bats, and scorpions.

At the next corner, in a cluster of hat cubicles we find furs of lynx, leopard, mink, dog, wolf, and fox. Obviously, political correctness is nonexistent here, and it would be difficult to explain this term to men selling such fur hats. We see belts made of dog fur worn to warm the kidneys during the frigid winters. We choose a booth and prevail on the proprietor to find us hats made of rabbit. Our justifications are that no parts of rabbits are wasted, while the others are slain only for their pelt, and that there is a distinction between eating a predator and prey, though I'm not certain how the latter rationalization arose. Actually, we are tempted by the exotic furs of the carnivores, as warm hats are

necessary in the frigid mountains of New Mexico and those of the meat-eaters are softer and more sumptuous than those of the common hare. But we resist and come to an agreement on rabbit hats with earflaps, as we don't want irate rights activists throwing paint on us when we get home.

We have shifted our search for treasure from modern art to authentic, local handcrafted goods, but to do this often we have to impose our will on our tour guide. The guides seem to work for independent companies that contract with Julian. They are accustomed to larger groups where the itinerary is controlled and are regularly stunned and stumped by our requests. For example, in Xi'an I e-mailed Julian and told him we wanted to eat in the local restaurants. He warned me that this can be risky, but we now consider it mandatory. When we ask the guides to take us to local craftsmen, often they tell us that they'll have to check with the owners of their companies or a fellow guide to find the locations. The scheduled itinerary regularly includes carpet factories, probably because the tour company gets kickbacks. One guide even asked us to sign a form saying we declined this destination, the tour company being intent on imposing *its* will. Once, when we made it clear to our guide that we had no desire to see carpets but Kathryn needed a pit stop, we were nevertheless told that to get to the only clean restroom she had to walk through a carpet factory. In their defense, the economic slowdown and political unrest have devastated tourism in many of the cities we are visiting, so promoting business is understandable.

After leaving the Sunday market, we head to destinations I have been anticipating as eagerly as the animal market: local instrument stores to find the makers of the types of instruments I saw at lunch. In the first shop we locate, the Aysahan Uyguhur Musical Isterments [sic] Factory, the shopkeeper, Kurbanjan, a fifth-generation instrument maker, is carving a fingerboard as we arrive.

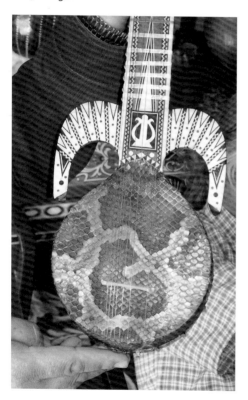

Rewap with python face, Kashgar

There are seemingly a dozen different varieties of each stringed instrument played by bow or plucked with the hand, each elaborately decorated and variously contoured, including oval, angular, and pear-shaped. A ten-foot-long intact python skin hangs waiting to be used as the face of one of the many stringed instruments. Elaborately painted and decorated gourds hang above, which are either drums or rattles. A standing ornamented chubby bass leans against a fresco of gaily festooned musicians. After we inquire about the instruments, we thank Kurbanjan for his time and leave to visit the competing luthier.

In the second shop, there are more instruments and a mysterious back room littered with instrument components. I am taken with an ornately designed twelve-foot-tall lute as an art object, but on closer inspection I note that the workmanship is below

standard and the finish deteriorating. Then I am drawn to a rewap, a Kashgar fretted model with a long neck, small bowl, and python face, elaborately carved and inlaid with two hornlike appendages protruding from the bowl. I make an offer but soon discover that the prices at this shop are higher than at the other. Consequently, we return to the first shop, where I locate a fine rewap with rich resonance and negotiate a price, which represents half of Kathryn's birthday gift to me. Unfortunately, later when I ship the rewap home the two horns break off despite the fact that it was in a hard case, then packed in a box. Disappointed, I immediately take it to a local guitar shop, where luckily the owner tells me the breaks are clean and he will be able to make appropriate repairs.

It is almost the end of the day, and as it is our sole opportunity to shop in this outpost halfway around the world Kathryn wants to look for jewelry. Aashif takes us to a couple of shops that may have antique jewelry, although it seems more like dusty junk appropriate to a flea market or secondhand store. At other jewelry stores, Kathryn becomes intrigued by local 24k gold earrings fashioned in a four-hundred-year-old style. Since we aren't used to 24k gold, we are hesitant as it seems the posts could break when put through the ears, but Kathryn finally buys a pair. The shopkeeper does not take credit cards, so I leave with the shopkeeper, who hires a taxi to take us to the ATM for China Construction Bank, and I withdraw the appropriate amount. It is a bit eerie driving through a foreign city to get money, but I trust that Aashif would not have us abducted, and we return safely to complete the transaction. During

and deer jerky and am tempted, but we buy some gorgeous pashminas instead then check in for our flight to Urumqi.

While waiting to depart, I reflect on some aspects of our trip thus far. I find there are stops and starts in a month's travel. Yesterday we were in a rhythm that made sightseeing easy, but this morning my body and soul crave a couple of days at home to regroup. Fortunately the waves of ennui are fleeting and temporary. We take turns at stomach discomfort and mild dizziness. Today, Kathryn's health is fine and mine is at 65 percent. On the plane she eats a boxed lunch of dried meat, cold packaged pressed vegetables, and hot beef rice, while I contentedly drink only Sprite.

Aside from timidity at eating today, so far on this trip I have been adventurous about cuisine, having eaten a great variety of foods, including fish ball soup for breakfast, which was good and not fishy; donkey cold cuts; lamb loin, which looked like a chop of both sides of the vertebrae and was grilled, topped with raw onions, and delicious; and plenty of high-quality vegetables, which in Kashgar comprise 80 percent of breakfast and are served sometimes pickled or in hot warming trays. We have taken to stir-fried eggplants with red chili peppers; fresh tofu, generally in a hot red pepper sauce; oyster mushrooms with green beans; Chinese cabbage twelve ways; fat, which is a food here, such as large lumps of sheep fat, some the size of bread dough; beer, which is served in a large bottle to be poured into small glasses in Han restaurants; in Muslim areas, tea or

pomegranate juice; and wine. In Dunhuang our guide, Arthur, helped us choose and purchase in a grocery store one of the better Chinese wines for about US $8, which was not very complex, but not bad either. We are also drawn to water, of which we can't get enough and are regularly buying by the liter or case.

As for the boxed food served on airplanes, fare often includes a packaged roll, inflated due to altitude; a packaged cake, like sponge cake but firmer; and a single raw zucchini. Often a hot tray with a rice-based dish accompanies the meal. On one flight, as I struggled with a small foil package of an indiscriminate, pickled substance, the man across the aisle gestured to me to mix the contents into the rice. Then he tried to avoid eating his by offering me his package. After feeling compelled to try the boxed food on the first two flights, I now pass when offered.

The main Chinese diet of vegetables, rice, and small amounts of protein, combined with exercise, such as riding bicycles and walking, has allowed the Chinese and Uighur people to maintain a certain level of physical health, although McDonald's and Coke have now become weeds in the fields of nutrition. Also, Chinese lungs are subjected to ever-increasing plumes of cigarette smoke and air pollution. It seems as though everyone in the country smokes, reflecting a 1950s Humphrey Bogart kind of machismo. In hotel bars and restaurants at least one, and frequently more, of the people in the parties light up.

Additionally, in their haste to transform a nation, the Chinese like Americans in decades past, tend to overlook conditions that contribute to pollution. Diesel trucks, buses, tractors, and carts produce a dismal haze, occasionally in billows. Many of the locals wear face scarves or surgical masks to minimize exposure to the pollution, which we retreat from when possible.

On a grander scale, the problem of pollution is exacerbated by earth movers, Caterpillar tractors, dump trucks, and cranes that deconstruct then help build new power plants, tunnels, airports, bridges, skyscrapers, roads, cities, and factories that spew the devil's air in both urban and rural areas. One night our five-star hotel windows were caked with a frosting of white ash, as was a jetliner window days later.

I recall the miles of mining debris on the drive to Karakul Lake—an austere landscape that for two millennia had been altered only by the tracks of sheep, goats, camels, warriors, caravans, and yaks but is now defaced by constant bulldozing and dam building. At this point, it might take an earthquake to repair the scene.

Further, we have yet to journey to a metropolis or village untouched by recent growth. The Han majority moves its people to minority regions to solidify its power, resulting in sprawl in ancient minority villages. The heart and intestines of most western Chinese cities are well-kept walled compounds, dilapidated buildings, mud dwellings, historic plazas, piles of construction rubbish, cranes, mounds of trash, government tenements, hanging laundry,

and in the larger cities, glass towers. Our conversation in Shanghai with the landscape architect from Kentucky revealed that his primary work here is quality control. While the contemporary landscape is constantly changing, obsolescence seems part of the equation, as evidenced by floor tile bubbling in a new airport, and cracks in glass and wood dividing walls around airport cafés. Often at first glance the appearance of things seems fashionable, but the timeworn adage "Appearances can be deceiving" is rapidly confirmed to a discerning eye.

Our attempts to communicate with Chinese travelers are minimal though well intentioned. On airplanes, we are regularly seated in a row with a third person who is Han. One man, out of curiosity, took the book Kathryn was reading and looked through it upside down, while another time a man demonstrated his rudimentary ability to read English, shaming us at our inability to read even a single Chinese character. Sometimes I attempt to communicate by finding a map of the world at the back of an airline magazine and pointing to the United States, saying, "America." When they have an understanding about our country of origin, I draw a dot for Santa Fe, and in some instances struggle to draw New Mexico. Often I point to Houston and say, "Yao Ming," as a cultural and geographic frame of reference, to which I receive excited smiles at the common respect for this basketball giant. These minimal efforts at communication, despite yielding limited information, help us feel closer to the local people.

At the Urumqi airport our guide Lilly greets us, and though our most pressing desire is a hot shower, we stop first at a Uighur restaurant for a lunch of red chilies and beef with peppers, which we learn contains flower peppers as Kathryn's tongue is numb after the meal. Once back in the car we see an ominous heavy military presence in this city of recent strife. Troops with clubs are on patrol. When questioned, Lilly explains that the Han and Uighur people are living in fear of each other, and she is saddened by the resulting separation. She repeats the official dogma that the strife was initiated by the Uighurs.

Finally, we reach our hotel, the five-star Hongfu Grand Hotel Urumqi, and discover that

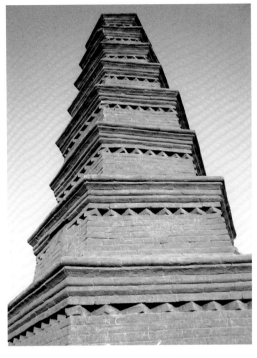

Red Hill Park, Urumqi

though the room is rather small the beds are plush and the tub and toilet are clean. After bathing, we drive to Red Hill Park, the highest point in Urumqi, for a panoramic view of the city. A tradition of commitment among many couples is to go to the top of this hill and together place a dangling lock on the iron fence. The number of locks indicates that many oaths have been taken here. Next, our driver drops us at the market area and we take a short walk in search of fruit. We buy three tangerines from a street vendor for a pittance,

passing a woman leaving a boutique with a foo-foo dog ridiculously attired in a coat and four tiny boots. We cross back to our hotel and retire after an early dinner there. We have found Urumqi, a rather new city of 2.5 million people, of little interest.

Pandas, Brocade, and Unrest

TUESDAY, OCTOBER 27 ~ URUMQI–CHENGDU

Today we fly from Urumqi to Chengdu. Of the 130 passengers on this Airbus 319, 128 are Chinese—Kathryn and I are the 2 exceptions. Though we are regarded as somewhat of a curiosity, we have been welcomed by our Chinese hosts, who seem both warmhearted and inquisitive. Most often our smiles and gestures are mirrored by our hosts, who are as fascinated with us as we are with them.

Then there are the fundamentalists, visible in public squares, mosques, churches, and military parades. Communists here, like right-wingers in the United States, seem to feel an imperative to dictate their moral values. And television, especially twenty-four-hour news, provides them with a breeding ground by continually stoking the fires of insecurity and fear.

Due to the friction between the Han and Uighur people, which culminated in the July riots, the Chinese government shut down the Internet and international phone service in Xinjiang Province. Now, over three months later, military presence is obvious and effective. We regularly see the Chinese army and local military ants in a bleak police state effort to quell any insurrection. Government action is swift and harsh. In four days we are to learn that nine Uighurs have just been sentenced to death and executed, and an area as large as Texas has been cut off from external communication, though CNN and BBC can be seen some places. It is a bizarre twist that where toilets are filthy information can be sanitized. People of the Xinjiang Province suffer as business is restricted and tourists, on whom a significant slice of the economy depends, are scarce. The restrictions and nightly convoys have little impact on us; even so, I fantasize about being captured and broadcast on national Chinese television, causing my diminutive yet formidable Jewish mother, upon seeing her son's image, to frantically phone her congressman and the president.

Around midnight, I am awakened by a call of the wild. The wolf has growled in my intestines and begun barking. I take necessary measures, including a dose of Imodium, and hope for a satisfactory tomorrow.

WEDNESDAY, OCTOBER 28 ~ CHENGDU

Kathryn awakens excited, as today we plan to see the giant pandas. After a forty-five-minute drive to the northern fringes of Chengdu, we arrive at the Giant

Panda Breeding Centre, the world's largest research and breeding center for pandas. The Chinese are rightfully proud of their efforts to maintain the panda population. We are first introduced to a newborn panda, which to Kathryn appears like an alien with a corresponding screech. Then we wander to see the adult bears in the ample, well-planned grounds, and find the lumbering giants seemingly content eating their morning bamboo. Surprising and notable are the red pandas, smallish animals with bushy tails, built more like badgers or weasels with the faces of auburn raccoons than like the black-and-white gentle giant pandas. While Kathryn delights in what she jests is her pandamania, the skittish creatures in constant motion create a game of hide-and-seek for the tourists. Many red pandas seem to have scruffy, stripped tails, a result of their internecine combat. Though I applaud the center's efforts, the place

Giant panda, Chengdu

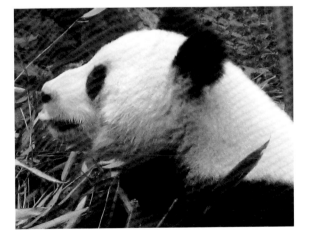

leaves me longing for a more visceral experience, as when I came around a curve in the rock grotto of Ernst Tinaja in Big Bend National Park and stood face-to-face with a hissing rattlesnake, or when on another occasion at the same destination I chanced upon a Mexican black bear.

After visiting the Giant Panda Breeding Centre, we go to a museum built 40 kilometers west of Chengdu on an archaeological

site, Sanxingdui, discovered by a farmer in 1929. Here in 1986, two major sacrificial pits were found that aroused academic interest around the world. The Sanxingdui finds are exciting but remain enigmatic. To date, no written records of this five-thousand-year-old civilization have been found. Kathryn notes: "Enormous bronze heads reminiscent of Inca masks fill the museum. The culture's dexterity and competence with bronze is astounding…. There is also a photo of 'Roosevelt' visiting the ruins…upon closer inspection of the photo, it was clearly not Roosevelt." I go into the museum with Kathryn and our guide Laura and observe the artifacts for ten minutes or so, then, weary of relics, retire to an outdoor bench to "people watch" for the duration of our visit.

Though Chengdu is internationally known for the Panda Research and Breeding Centre, for most of its history it has been better known as the Brocade City. Not only does the Brocade River run through the center of town but the silk fabric with raised designs known as brocade has been a treasure here since the Han Dynasty, over two thousand years ago. Laura takes us to a wonderful brocade factory, Chengdu Shu Jin Zhi Xin Co., Ltd., that captivates us with a dazzling array of colors and textiles, the highlight of which is three large looms down a few steps in the center of the space. Each loom—a wooden frame structure, about twelve feet long, three feet wide, and eight feet tall—is like a small sailing vessel strewn with lines connecting threads and colors in patterns that take the designer two months

each to learn before it can be woven into the fabric. Since the patterns are so complex, the same motif is woven for a couple of years in a row. Weaving on such a loom is a two-person dance worthy of the Olympics, where the person on top, balanced as if in a crow's nest, controls the warp, sorting and raising the threads by color to create the design, while the person below controls the weft, using shuttles to weave the chosen colors into the brocade. This is not a craft for the impatient or clumsy, and requires as much precision as playing any instrument in the Kashgar Insterments Shop. Though the craft apparently lost adherents for a while, fortunately there is now a small but devoted colony of weavers.

As an endorsement of their passion, the men working on the looms are dressed in silk brocade. And surrounding the looms is an array of elaborate brocade: women's jackets, men's jackets, pillow shams, table runners, table-cloths, children's clothing, purses, and Chinese images, as well as bolts of brocade material. Kathryn finds two jackets she likes, one green and the other red, lavishly embellished with sequins and metal discs, and because she can't decide between them, we take both as the prices are very reasonable. I select a brown silk smoking jacket with about twenty-five knotted buttons, or frogs as they are known, adorned with red brocade on two lower pockets. We also choose a table runner with two dragon images, as well as two pillow shams. Our total bill is about US $600, the same amount a boutique in the United States would charge for only one of Kathryn's jackets.

Laura confirms that we want to try local cuisine, and our driver drops us at the steps of a three-story building. Inside we are greeted by a mob of delirious diners, all Han, enjoying hot pot. Laura sees that we are seated at a table in the center of which is a cauldron. Inside the cauldron, the size of a large, deep wok, is a second chamber with a broth of a different color. The waiter arrives, lights the propane or butane tank under our table, and begins to add to the outer chamber about eighteen red chilies and some flower pepper, the same small, berrylike spice that numbed Kathryn's mouth in Urumqi. Laura stops them from adding more, saying that this is about half the amount they would add for locals. The broth in the inner inner pot, now boiling, provides the cooling mechanism to counteract the fiery chilies.

Despite being in a place where hot pot is a specialty, this is the wrong time for my hot pot adventure as I am still queasy from the night before and only crave Sprite, but Kathryn holds her chopsticks in excited anticipation. We are first offered pig's intestines, brain, and fish. Soon a waiter arrives with three live baby catfish, sliced diagonally three times and wriggling, but I send them back. Laura puts slices of beef and chunks of potato into the boiling oil and stirs the broth with her chopsticks. Although my whole being is initially repulsed by food, finally I try some of the meat and vegetables, then the brew in the inner pot, only to find a hamhock camouflaged in its oily stock. I gag and am relieved when we leave, though I take solace in the fact that Kathryn has savored this culinary inferno.

THURSDAY, OCTOBER 29 ~ CHENGDU–LHASA

This is our last morning in Chengdu, and we visit Wangjianglou Park to see the bamboo forest for which the park is famous and to experience a traditional tea ceremony. The main landmark of Wangjianglou, which means "river view," is the Wangjiang Tower, a one-hundred-foot four-story ornate Chinese-style building. The first two floors are square, representing earth, and the upper two are circular, representing the heavens. The tower is surrounded by ornate gardens with poinsettias and bamboo rails around massive stone arrangements. Elaborate and colorful woodcarvings adorn the curved cornices, into each of which is carved a story with human figures and symbols: one has a pig with a sword through its belly, another a bull, a third a dragon. While our search for contemporary artwork has been frustrated, these carvings, each more dazzling than the one preceding it, satisfy our search for beauty.

The park also contains China's largest assemblage of bamboo species, and we view many varieties, including alligator, square, miniature, and giant. The site is also well-known for being dedicated to the famous poetess Xue Tao, who lived here from AD 770 to AD 820, honored in the park with a white marble statue. Kathryn notes gruffly that the female poets were automatically considered inferior to the males.

Next we head toward the tea garden, where we watch perhaps a dozen Han exercising slowly in unison through an opening in the screen of bamboo. In another bamboo glade, we are treated to the sight of twenty dancers in

The famous poetess Xue Tao, Wangjianglou Park, Chengdu

flowing white shirts and trousers; we ask if they are members of Falun Gong, and Laura deftly replies that they are practicing another type of martial art. We then witness, in a large plaza abutting two teahouses, a few hundred couples passing their morning in an outdoor ballroom dance. Finally, we sit at a table for our tea in this bucolic setting, with the dancers to our right, the movement of the white-clothed people visible through the bamboo, and mahjong players beginning to sit in bamboo chairs at tables near us. We are more interested in the mahjong players than the tea; Kathryn inquires if she may take a photo, and the groups gesture their permission without losing their concentration on the day's moves. The serenity reflected in these age-old activities is riveting.

Eventually we arrive at the Chengdu airport and prepare to board Air China flight 757 to Lhasa, Tibet, which, along with Kashgar, is the destination we have most anticipated. I cannot help but notice that the restroom reeks of donkey urine. An old man mops the floor, spreading the moisture to the soles of each departing traveler.

As we travel, we continually confirm that the most powerful export of the United States is our culture, signs of which can be found in China on roadside

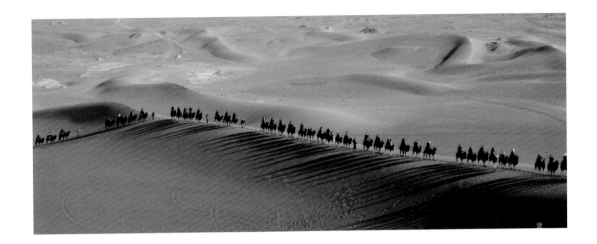

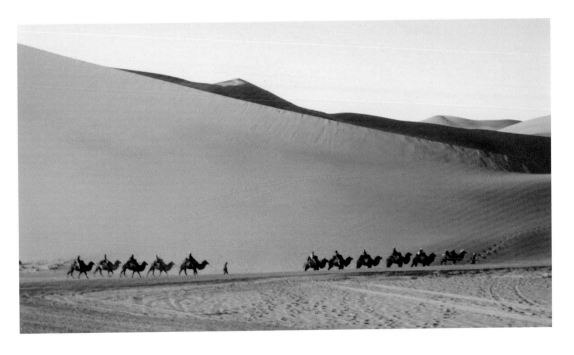

Camel Ride, The Singing Sand Dunes, Outside Dunhuang

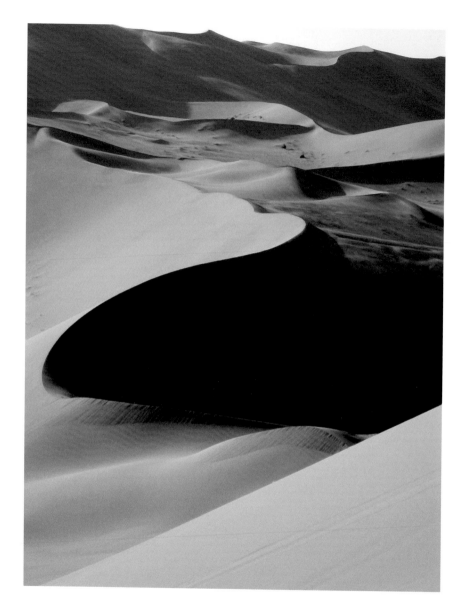

The Singing Sand Dunes, Gobi Desert

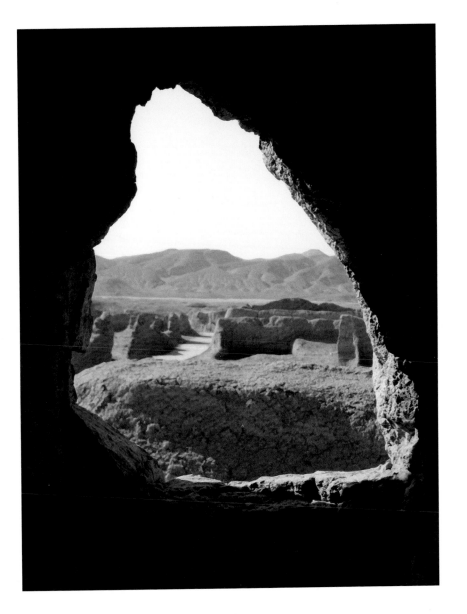

A Timeless View, Jiaohe Ruins, Turpan Depression

Buddhist Enclave, Flaming Mountains, Taklamakan Desert

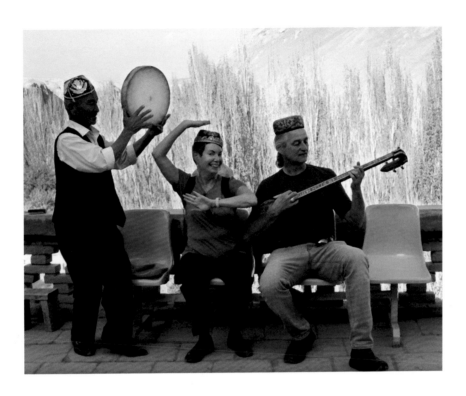

Troubadours, Bezeklik Thousand Buddha Caves, Outside Turpan

Roadside Butcher Shop, Opal

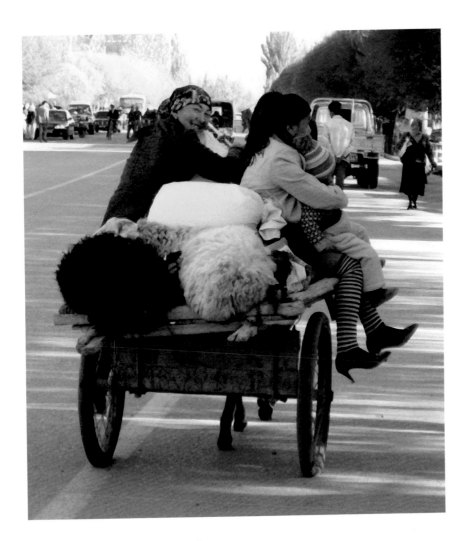

Laden with Children and Sheep, Opal

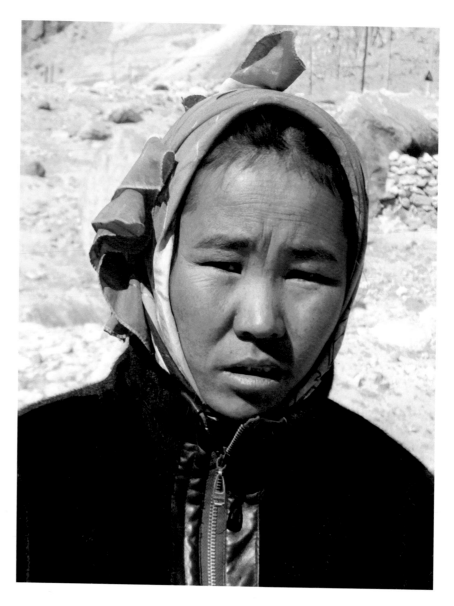

Our Kyrgyz Friend, On the Road to Karakul Lake

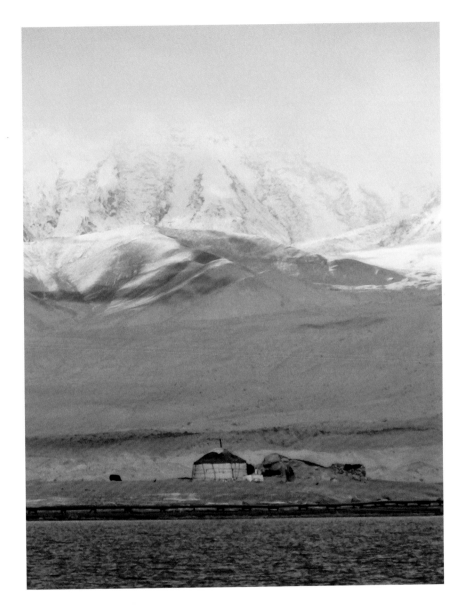

In the Shadow of Muztagh Ata, 60 km from Tajikistan, Karakul Lake

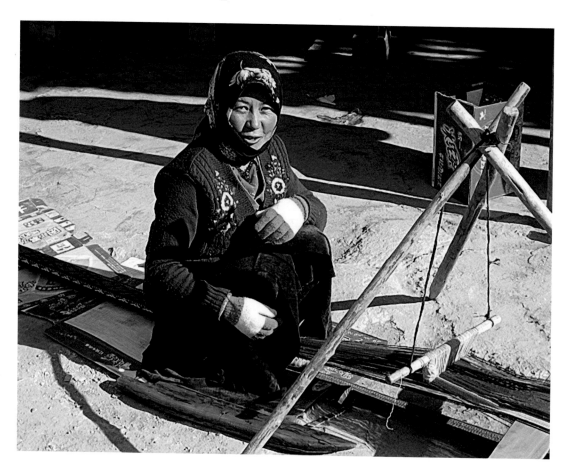

Weaving at Roadside Checkpoint, Karakoram Highway

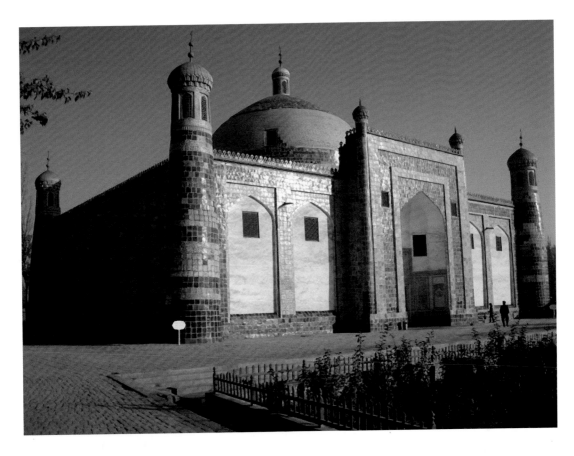

Fragrant Concubine's Tomb, Kashgar

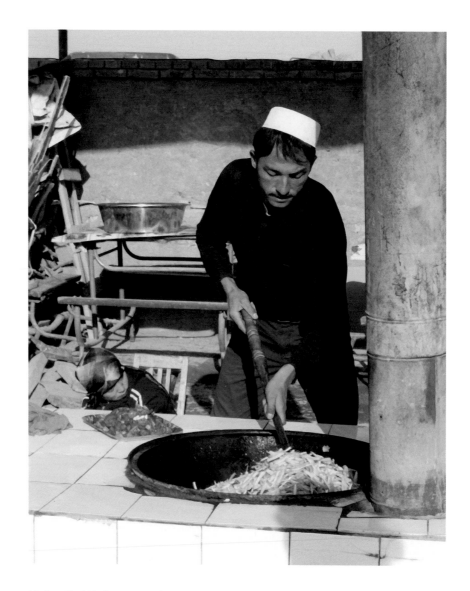

Uighur Chef, Kashgar Animal Market

Muddy Goats, Kashgar Animal Market

A Fine Purchase, Kashgar Animal Market

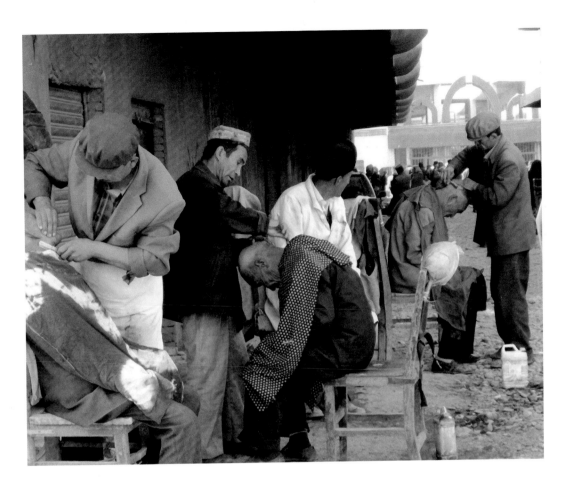

Sunday Shave, Kashgar Market

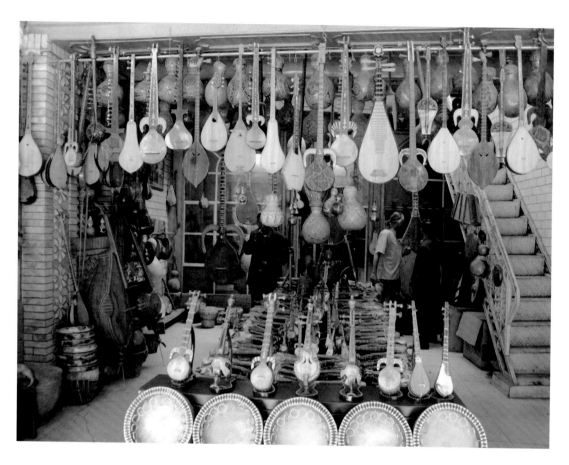

Uighur Instruments, Kashgar

Strands of Garlic, Kashgar Market

Mahjong Interlude, Wangjiang Park, Chengdu

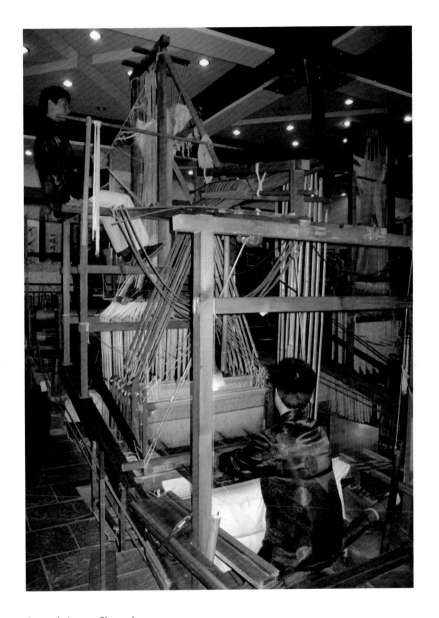

Brocade Loom, Chengdu

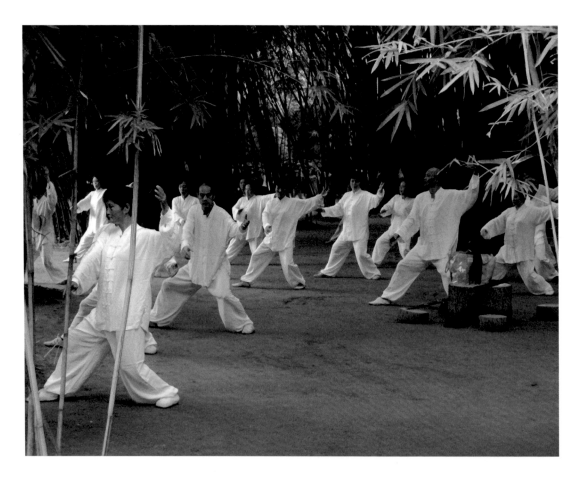

Morning Martial Arts, Wangjianglou Park, Chengdu

Morning Tea, Wangjianglou Park, Chengdu

Tibetan Hair Adornments, Lhasa

Grinding Paints, Dropenling Handicraft Development Center, Lhasa

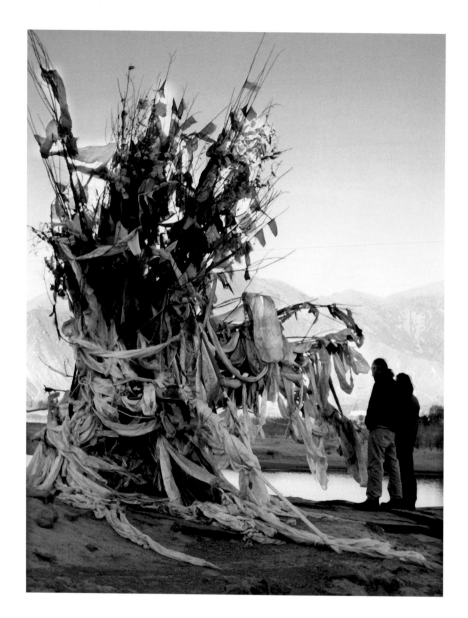

Prayer Flags above River Burial Site, Road to Gyantse

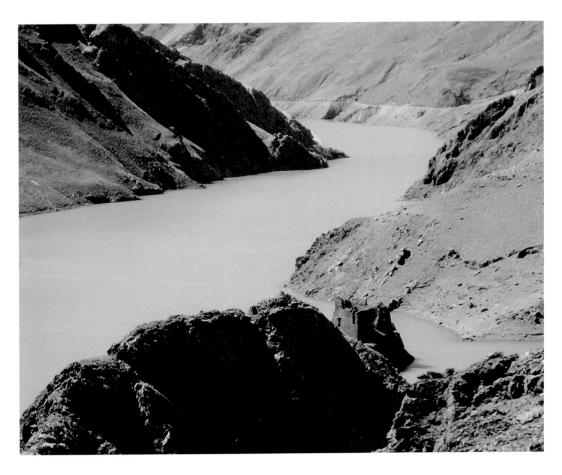

Searching for the Lake Fairy at 16,385 feet, Yamdrok Yumtso Lake

The Monks of Tashilunpo Monastery, Shigatse

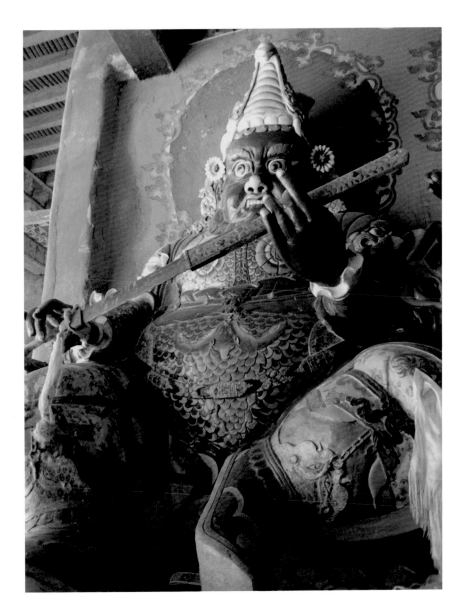

Guardian of the Temple, Gyantse

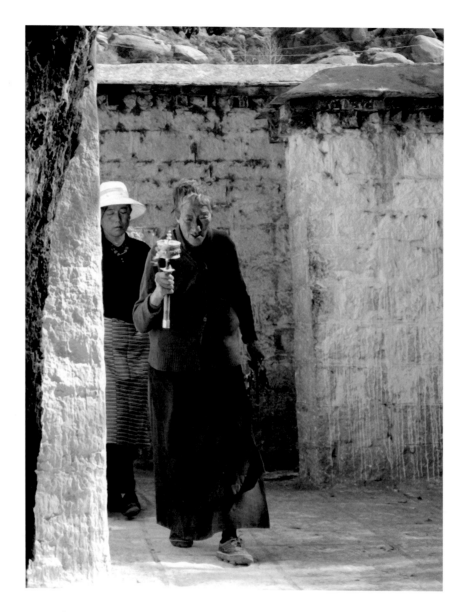

Prayer Walk, Sera Monastery, Lhasa

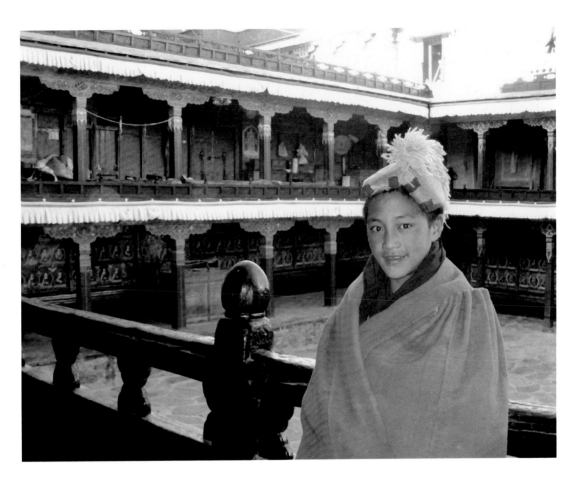

Novice Monk, Tashilunpo Monastery, Shigatse

Handmade Kite, Grounds of the Temple of Heaven, Beijing

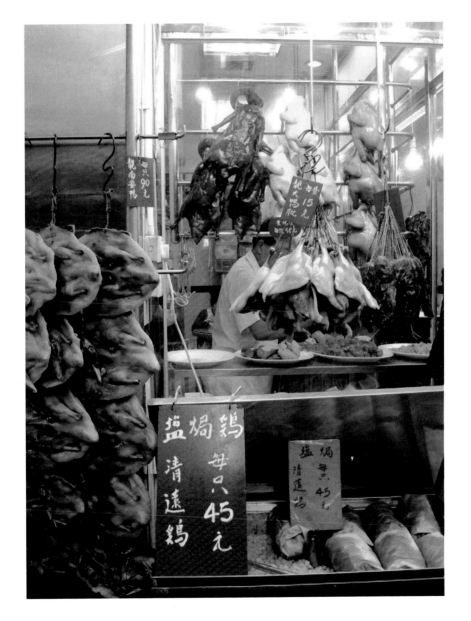

Roast Ducks and Pork, Hong Kong

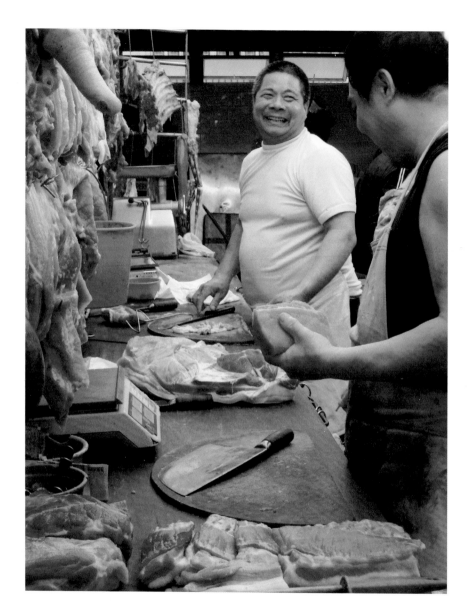

Happy Butchers, Hong Kong

billboards, merchant's walls, convenience stores, and T-shirts. Perhaps our best hope of freedom for the Chinese is that our increased ties will continually erode their flawed political system, though I wonder if it takes a totalitarian system to lift a billion people out of poverty. As the son of Holocaust survivors, I have an innate distrust of any regime based on control of ideas and access to information, and know that the US government is not beyond reproach in restricting freedoms in response to xenophobia, from the internment of Japanese in World War II to the attacks on rights to privacy in response to 9/11. Hopefully, the current Chinese political system has opened a Pandora's box regarding its future by allowing more sales of American products and access to American culture, although there are still many signs of government control. On the one hand, the government swiftly silences the voices of a region we are about to visit, Tibet; on the other hand, we see English mastheads on local versions of *Cosmopolitan*, *Vogue*, *Elle*, *Reader's Digest*, *Sports Illustrated*, *Motor Trend*, and Chinese characters on local versions of what might be *Time* and *Newsweek*. Likewise, we pass shops with Samsonite luggage and Wrigley's gum at the airport.

Kathryn writes: "While waiting to board our flight to Lhasa, there is an older, distinguished-looking Tibetan gentleman in a tired brown suit, wearing a fedora and patiently sitting with a much younger Tibetan woman in traditional dress—ankle length, nondescript, topped with a striped apron. She seems to cling to the elderly man, who looks tired but peaceful and almost

ethereal. I gaze at him, and his piercing blue eyes stare back. I nod and smile, and he returns the friendly gesture. When the boarding call is announced, the man, accompanied by his traveling partner, lines up to enter the plane, and in typical celebrity fashion passengers approach him shaking his hand and asking for his autograph. During the three-hour flight, the gentleman sleeps while his companion clasps his arm. I later learn that the man is probably a living Buddha, a rare consciousness that can be achieved in keeping with Chinese Buddhist beliefs."

I watch through the window of the plane, flying at 25,000 feet, wonder if a mountain peak might scrape our underbelly, and find it strange that we will land at almost half the altitude at which we fly. We have been warned that upon arrival we should move slowly, keep hydrated, and avoid a warm shower, which uses energy the heart would have to replace, requiring more oxygen.

Upon our arrival in Lhasa, we are greeted by our local guide, Bruce, who immediately drapes our necks with *hadas*, white silk scarves symbolizing longevity and respect that are often used as a greeting gift. Bruce looks like he could be the guide of a mountain expedition, with his shock of jet-black hair, youthful vitality, and red North Face jacket, which he later tells me is Chinese North Face and not to the standards of our North Face. Our view of Bruce becomes more complex, however, on the forty-minute drive to Lhasa. On the one hand, I hear propaganda from him as we pass through a wide valley punctuated by a forked, meandering river, the longest bridge in Tibet, and the

longest tunnel in Tibet. On the other hand, Bruce is knowledgeable about Buddhism and carries two photographs of himself with a monk from a monastery built six hundred years ago. With his sandalwood prayer beads and North Face jacket, it becomes apparent he is torn between two worlds—the modern Chinese world and the world of traditional Buddhist culture. Buddhism is more fervent in rural areas of China, while managed capitalism seems to be the religion of Shanghai and the populous East.

Bruce says we are his final tourists of the season and indicates his plans for ongoing education, required of tour guides—I assume by party officials. Indeed, as Bruce begins guiding us, I sense that he is parroting party propaganda. We are told at least three times that if we have brought papers which might cause unrest we should turn them over to him or to a policeman. I assume our young and impressionable guide would be rewarded for rooting out subversives. I start wondering where to hide my journal while in Lhasa and even imagine the government eavesdropping and recording information in our hotel room.

Bruce also instructs us not to go out at night, as some nefarious characters might attempt to glean incendiary information from us. At this point I realize that the party would be best served if he would stop talking, as his preaching is only making us rebellious. We may not have arrived with a political agenda but are quickly becoming sympathetic to one. A friend at home decried our proposed travel to Tibet, implying that it amounted to moral irresponsibility,

but on the contrary, our inclination to reject and protest the political situation in Tibet is being strengthened by being here and hearing China's propaganda. We see a clear necessity for change. We know that dynasties along the Silk Road collapse, and have experienced the fear that dictates evil. We pray for Tibet and, as we travel through the region, confirm that it is the Achilles heel of an immoral policy.

We are seeing that China is not a Communist country so much as it is an imperialist and totalitarian one. Though the landscape is littered with "people's parks," "people's squares," and statues of Chairman Mao, the government is less focused on the power of individuals than on the power of the state. In fact, for most of the world totalitarianism, whether due to a succession of emperors, kings, czars, tribal chiefs, or military juntas, has been the historical norm. And regardless of whether a country's totalitarianism springs from the power of one person or one party, the result seems to be the same: lack of freedom, suppressed expression, and homogeneity among its citizens. Plus really bad TV.

Our host at the four-star Sheraton Hotel in Lhasa is a finely tailored, regal-looking Egyptian who prefers managing hotels in exotic locales and consequently plans to stay in Lhasa while opening the five-star addition next door. His daughter is attending American University in Washington, DC, which I find amusing, as we seem to be from different worlds yet my son also attended college in Washington. With his sparkling personality and shiny

bald head, we endearingly anoint him our Coptic genie. Also present is the hotelier, a woman with an interest in Thangka paintings and antique Tibetan trunks. She has acquired many traditional paintings for the hotel, including one we especially like of an ominous tiger. Though her Thangkas appear to be antiques, she concedes that the depictions are recent commissions while the doors on which they are painted are the true relics. We are frustrated that our schedule does not allow for a detour to the workshop of these intriguing wooden "canvases."

As we rest at our hotel in the afternoon, Kathryn is awakened from her daily meditation and uncharacteristically runs out the door to the street-side windows to investigate the source of her distraction, which turns out to be the Chinese army marching in unison and chanting. This occurs twice daily, like clockwork. We soon discover that the military presence in Lhasa is heavy and its intent unmistakable. Any dissent, however mild, will be aggressively suppressed.

In 2008, there were major conflicts here as Tibetans protested on the forty-ninth anniversary of the failed 1959 uprising against Beijing's rule. Monks began the protest, and hundreds were arrested. The Chinese overlords attempted to blame the unrest on the Dalai Lama and were particularly furious as they were orchestrating a world show for the upcoming Olympics. It is clear to us that we are in an occupied territory; and while the Chinese have made some physical and infrastructure improvements to open Tibet to the world, they are an unwelcome occupying force.

The fact that China has many neighboring countries creates numerous political pressures. Western China shares borders with Kazakhstan, Kyrgyzstan, Tajikistan, Afghanistan, Pakistan, and India; southern China with Nepal, Bhutan, Burma, Laos, and Vietnam; to the north and east are Mongolia, Russia, and North Korea; and across small seas are Japan, Taiwan, the Philippines, and Malaysia. Many of these borders serve as seedbeds for potential conflicts.

We eat dinner at the highly recommended Tibet Steak House. I feast on yak stew—which is delicious, the yak not much different in taste or texture from beef—corn soup with chicken, white rice, daal, and greens. Kathryn's plate is similar except for tandoori chicken. Although we are enjoying the meal, Kathryn confides that she craves enchiladas and a margarita upon our return to New Mexico. I understand the yearning, but mine at the moment is for dietary control and detoxification from Pepto-Bismol and Imodium.

On Top of the World in Tibet

FRIDAY, OCTOBER 30 ~ LHASA

This morning we are driven to the Dalai Lama's Potala Palace. Only two thousand people per day are allowed into the Potala, and we are excited to have the opportunity to visit. As we near, we pass Tibetan Buddhists on pilgrimage to Lhasa and locals in procession twirling Tibetan prayer wheels clockwise while circumambulating the city. The spinning prayer wheels of silver, gold, bronze, and turquoise, whether simple or lavish, contain thin pieces of paper scripture, most commonly copies of the mantra *Om mani padme hum*, meaning "Hail to the jewel in the lotus," entreating Buddha for compassion.

As we climb the steps of the palace, we are both hurried and slowed by pilgrims: women, their mid-back-length charcoal-colored hair braided and decorated with large jewels and wearing golden earrings laden with either

turquoise or coral; a baby hanging from a papoose with a slit for his little tush and business; and two crimson-robed monks leading a Western-suited monk up the steep, narrow steps. Kathryn notes: "People are very poor, with dark faces and red cheeks. The women's hair is braided with string, sometimes with huge chunks of turquoise and silver tied to the tops of their heads that bob as they walk. Monks wear robes. Pilgrims with babies tied to their backs clutch small bills and bags of yak butter as offerings for a long life. They wear long black skirts with striped aprons, and often tennis shoes."

Our ticket stub, with a hologram on the front side, depicts the massive white base of the Potala with the red main palace of about seven stories topping the fortress and a mighty snow-covered peak in the background, though upon closer inspection we see no peak. The ticket tells us that the Potala was built in the seventh century and expanded to its present size by the fifth Dalai Lama in the seventeenth century. The palace is divided into two sections, the red and white palaces, and rises thirteen stories. Within the palace are living quarters, temples, funeral stupas, and monks' dormitories.

*Grandeur of
Potala Palace,
Lhasa*

We stop at the smooth-timbered, ornately latched, and brightly adorned entry door for photos; then Bruce escorts us quickly through room after room of relics, murals, statues, and burning candles. Although from the outside the palace is imposing, dominating the skyline of Lhasa, I am stunned at the darkness and dankness of the interior. The floors and labyrinth of steps are waxy from the burning of yak butter candles. A monk scrapes the floors with a trowel and bucket to remove the yak butter that coats the slick stone—a Sisyphus-like task. One-cent notes are stuck in every crack and crevasse as offerings from pilgrims, their value insignificant in purchasing power but highly esteemed as gifts from the poor.

Hair adornments, Lhasa

The treasures in the palace are invaluable. One or two would be prized by any museum in the West, a dozen regarded as a noteworthy collection. However, there are thousands, in room after room, accoutrements to the larger Buddhas that dominate most rooms. After a while the gold and jewels seem overdone, especially in light of the poverty of the people.

Here in the Potala, we are challenged by the great disparity of wealth that existed in Tibet between the religious leaders and the ordinary people, reminiscent of that between the Catholic Church and its parishioners in Europe; in both cultures, wealthy and powerful religious figures ruled over

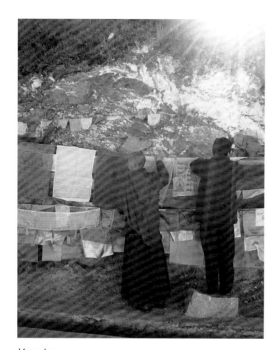

Hanging Tibetan prayer flags, Lhasa

subjects who suffered a life of poverty mitigated by hope for a better afterlife. Earlier when I discussed Tibet with a friend and longtime Buddhist, he allowed that the Dalai Lama acknowledges the Buddhist leaders failed their people, accumulating palaces instead of adhering to Buddhist tenets, and that the Dalai Lama's current situation in exile was the result of karma. Although I do not know whether the Dalai Lama is an appropriate leader for Tibet, it is clear that the current oppression of Tibetans benefits only the People's Republic of China. Our greatest fear is that it will eradicate Tibetan culture. So I vote to reinstate the Dalai Lama to his rightful position in Lhasa, as the hegemony and cultural adulteration by the Chinese overwhelm any of his past transgressions.

Finally, we exit the Potala down a long ramp, past groups adding to the thicket of prayer flags, irreplaceable fallen stones with ancient religious inscriptions, and large, ornate, two-foot-high brass prayer wheels lining both sides of the walkway, being spun by pilgrims. We, too, spin these rotating cylinders, like children spinning orbs at a planetarium. We pass the Potala, both on foot and by van, perhaps a half dozen times during our stay, convincing us

that the view of the whole from afar, dominating the city, remains more commanding than the view from the dusky throne rooms.

SATURDAY, OCTOBER 31 ~ LHASA

Our morning's destination is the Dalai Lama's summer palace, the Norbulingka, a few miles from the Potala and surrounded by gardens. Here we see rooms where the Dalai Lama studied with his tutors and met with dignitaries, which by no means seem luxurious, though we note the Western-style bathrooms. The Dalai Lama's mother was not allowed inside the palace, as his studies were dictated by his male teachers. Pilgrims stare at us curiously; we watch as they stuff their precious currency into nooks and crannies of all sizes while devoutly touching their foreheads to the statues and furniture. We stop at the small shop operated by monks and converse with the shopkeeper, who speaks perfect English. She helps us choose two prayer wheels, one covered in turquoise and the other brass, and warns us about our guide taking us to buy "fakes."

A personal highlight of our visit to Norbulingka is the huge Tibetan mastiff on the roof of the entry, chained, running back and forth barking at all passersby—aggressive, black, imposing. This animal has been bred for centuries to protect flocks and is said to be a ferocious guard dog, unafraid of wolves and leopards. As the Chinese have become wealthier,

Tibetan mastiff on roof guarding Summer Palace, Lhasa

mastiffs have taken on status like a Ferrari or Porsche; a good breeding dog can fetch thoroughbred prices. Another highlight is the Tibetan ditch diggers who lift their faces from their task and shout "hallows" with huge welcoming smiles, drawing us in. In an interesting example of teamwork involving a man and a woman, the man digs into the dirt and the woman, using a strip of cloth draped around the shovel, pulls upward to complete the task.

As we walk through the main shopping plaza of Lhasa, the Barkhor Street Bazaar, we pass dozens of outdoor vendors selling prayer wheels, prayer flags, combs, silver jewelry, and assorted bric-a-brac—many items made in nearby Nepal. One woman grabs Kathryn by the wrist and attempts to coerce her into looking at her wares. Vendors on both sides chant, "Cheap! Cheap!" in a vain attempt to attract us. Outside the Jokhang Temple are women and children prostrating themselves on the ground, paying homage to their deities. This, one of the oldest and the most sacred Buddhist temples in Tibet, reflects a combination of Tibetan, Indian, Nepalese, and Chinese architecture. From the rooftop of the four-story building, we get a bird's-eye view of the bazaar, along with a close-up look at the ornate, gilded-rooftop viewing tower with its golden dragons and large gilded prayer wheel attended by a gilded deer on either side. Below, two large urns burn incense and two tall poles outside are thickly wrapped with prayer flags.

When we leave the temple, Bruce, who has contracted hiccups, causing his utterings to become abrupt and disconnected, leads us to a department

store of sorts as we've asked him to take us to see local crafts. The goods are laid out as if in a tourist superstore, and as we wander, the lights are turned on department by department in an attempt to encourage us to make purchases, but we are not interested in these pedestrian offerings.

Bruce then takes us to Lhasa's Muslim Public Square, outside the Lhasa mosque Qing Zhen Si, where the streets are crowded with a hundred or so Muslim businessmen who have traveled to

Construction of copper Buddhas, Dropenling Courtyard, Lhasa

Lhasa to make their living. Dozens more, donned in white head coverings, sell their wares in the surrounding shops as Chinese police stand patrol, armed with machine guns in a clear symbol of authority. Bruce leads us down a narrow street, and after a couple of blocks of shops we walk through a gate into the courtyard of the Ancient Arts Restoration Company, which, according to a brochure, "has restored Tibetan monasteries and temples for 30 years." Mushrooming around this company are half a dozen or more local crafts enterprises. In the courtyard, there is a constant background staccato as three or four men rhythmically hammer large copper Buddhas, repairing timeworn heads and constructing some anew.

At last, we reach the Tibet Artisan Initiative, also known as the Dropenling Handicraft Development Center, and here we discover the mother lode. While

scouring the store on a treasure hunt of local wares, I find a wool jacket with a colorful embroidered neckline; Kathryn is interested in the handbags but finds them too large. We purchase three paintings on boards in the traditional Tibetan style, two telling the story of how a monkey led an elephant to enlightenment, and the other looking like a grotesque and hilarious genie. Perhaps the highlight of our purchases are two horse blankets to become wall hangings in our home and cover decorations for this book, handmade by the Nagchu people, a nomadic tribe that supposedly has the highest altitude horse races in the world. Though we may not have found fine art, we have certainly found fine crafts.

We then explore the rest of the Dropenling Courtyard. In one shop, there are two rooms with four men making elaborate Thangka paintings. We have a mild interest in several of the paintings but do not purchase any. We walk next door and, through a tapestry, enter a room containing an old glass cabinet with mineral pigments and, on the floor, a number of dishes, like *metates* with *tejolotes*, or mortars with pestles, as well as women hand-grinding paints. Off to a side, there are two chests, about two feet high and three feet long, which have been hand-painted by these women. Interested, we inquire about prices but are momentarily distracted upon hearing of a vendor across the courtyard who sells antique Tibetan chests. We go to inspect them and cannot vouch for their stated ages of one or two hundred years old. Though we know there may be some bargains here, we don't want to take a chance on their authenticity, so we go upstairs and, using Bruce as interpreter, discuss with the shop's

owner prices and shipping of the freshly hand-painted chests. He doesn't have a clue how to ship a chest to the United States, so we go back to the Artisan Initiative, which is willing to help handle shipping.

This time the shopkeeper tells us that the first chest is spoken for and we can't really see the second chest as it is covered with remnants. He says he will be happy to send us another chest when it is ready, but due to some scheduling issues it will be more than half a year until he has another available. Ultimately, US $50 extra makes half a year disappear, and we have our chest for about US $600. We leave the chest with the craftsman making calls to DHL to arrange shipping, and are informed we must return to meet the DHL driver two days hence to finalize the arrangements.

SUNDAY, NOVEMBER 1 ~ LHASA–GYANTSE–SHIGATSE

We awaken in early morning darkness to explore the Tibetan countryside along the southern route, with an afternoon goal of reaching the small town of Gyantse. We drive through a valley wide with branches of the meandering Yalutam River, as Bruce calls it, although I find no Yalutam in my atlas. Our first jolt is a river burial site, our introduction to Tibetan burial rituals. Our driver pulls the van over near the largest accumulation of Tibetan prayer flags we have seen, perhaps several thousand, and looking from a ledge about fifteen feet above the river, we see what look like two small machetes or large knives a few feet below. The riverbank is littered with clothing of the deceased. We learn that

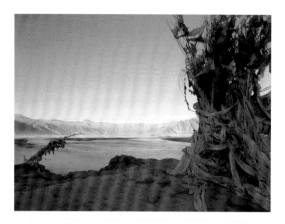

River burial site,
Tibetan countryside

upon a death, the monks bring the body to this place, first beheading it to allow the soul to travel to heaven, next dismembering the remains, and finally tossing them into the river. We are told that the water is deep in this spot, with eddies causing the body parts to sink to the bottom.

Soon after resuming our trip, we face a daunting series of switchbacks to a summit three thousand feet above. We are on a rocky slope that appears very austere, and as we rise through the switchbacks what initially looked foreboding becomes bewitching as we see thick-haired black and white yaks. Kathryn's cheeks are moist with tears of joy; she is having a transcendent moment of immense gratitude. She writes: "God touched this piece of earth as it reaches toward heaven. The beauty and magnificence brings unexpected tears. I am on holy ground." I acknowledge her transcendent moment, then assure her I am the same shallow person I was when we started. Kathryn's observations and mine are like branches of a river, sometimes at a confluence, sometimes a divergence.

Our guide tells us that at the top of the ridge there will be peddlers, muscular Kamgba people with red ribbons in their hair who migrated long ago from Germany to India and then to this remote region of Tibet. Legend has it that the Nazis sent troops from Nepal to Tibet to bring back the Kamgba in

their desire to create the super race. We are told not to look them in the eyes as it could provoke them, causing them to become violent.

At the summit we are approached by peddlers tending three or four yaks saddled with fine blankets, and are invited to take photos with one. Kathryn wants her photo taken, so we negotiate with the tribesman and she smiles while having pictures taken of her as yakgirl mounted on one of the animals. I am proud of her, but have no need to straddle a shaggy-haired ox. I do have a need for a quick pit stop at the nearby stone building, where, upon my exit, an old man tells me there is a fee for using the facility. This is beyond my comprehension, but I yield and pay, for I do not want these tribesmen to go postal on me.

Looking down the mountainside from our altitude of 16,385 feet, we see the pristine and holy Yamdrok Yumtso Lake, a stunning destination for summer pilgrims who come to pray for blessings from the lake fairy. We take a few photos and then run to the van to seal out the horde of jewelry hawkers who have surrounded it.

In Tibet, hawkers and beggar children are equally aggressive. The children, some as young as four or five, chase us upon our arrival at temples and almost jump into our vehicle. An earlier guide had warned us that if we ever gave children money we would be inundated. Sure enough, at one point

Decorated yak of the Kambga people, Tibet

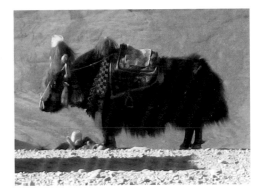

Bruce, after giving children a scrap of food, literally has to push them away from our van so we don't run them over while leaving.

As we continue toward Gyantse, we reach a plateau and see increasing signs of habitation until we are among endless farms, livestock, and homes. Regularly we yield to coarse-haired yaks, scruffy horses with winter coats, belled cattle, and errant dogs sleeping on the road. Imposing mastiffs terrorize our tires like Cato Fong terrorizing Clouseau as we cruise by, their barks and growls almost simultaneously shocking and vanishing. Kathryn notes that though most Tibetans are poor they richly adorn their livestock with brightly hued tassels, collars, and harness bells. It turns out that a dash of dye identifies ownership of sheep like a brand identifies cattle in the United States. When we see what looks like a TV dish but slanted and with a brass teapot secured in the middle, we are told this device is really an ingenious use of solar power to heat up tea in about an hour. We see dung patties, hand formed in the shape of small Frisbees, stacked everywhere near houses or used as siding and roofing, for dung is the fuel and insulation in this region, and a bizarre symbol of wealth.

Kathryn writes: "We are in the Jiangzi, one of the three richest agricultural areas in the Lhasa Sanlan Prefecture. The landscape is terraced by nature into flat, wide horizontal steps. The humblest stone dwellings have beautiful doors and windows trimmed with vibrant reds, blues, and yellows; intricate painting and elaborately pierced tinwork line the fronts and cornices. Groups of people dot the riverbanks gathering stones on blankets and dung in bags to carry

home. Each corner of the rectangular stone houses sprouts prayer flags. Clouds of dust trail vehicles on the unpaved roads to nowhere; mountainsides glisten with frozen rock. Golden copper tundra and a rain of boulders and rocks lie to our left and right. Glacier-fed rivulets flow by. Makeshift towns of glass and cheap facades rise from the land in hopes of luring tourists for lunch since the new road was completed in 2007."

Before approaching Gyantse, our guide asks permission to stop at a roadside restaurant as the driver hasn't eaten today. While they eat, Kathryn and I write, awaiting lunch in Gyantse, where we are assured of somewhat superior offerings. We reach Gyantse around midafternoon and surprisingly are taken to a restaurant with English signage, run by Nepalese. We are extremely pleased by our lunch of yak noodle soup, tandoori yak, and tandoori chicken. But Kathryn shudders as she returns from washing her hands in the restroom. We both find a decrease in our ability (and occasional dire need) to hold our breath for a long time, clearly a result of the high altitude.

After lunch we drive to Pelkhore Choede, a fifteenth-century monastery. We climb to the rotunda for a spectacular view of the Fortress of Gyantse Dzong and an up-close view of the saucer-shaped dome. Sadly, the Gyantse Dzong is in the outback of Tibet, and funds to maintain the deteriorating frescoes are sorely lacking. We leave for Shigatse with two children hanging on to our car doors looking for scraps. Bruce gives them a piece of bread, and we make a hasty and sheepish escape.

Upon our arrival in Shigatse, we visit the Tashilunpo Monastery, head-quarters of the Panchen Lama, leader of the Yellow Sect of Tibetan Buddhism, and seemingly persona gratis with the Chinese invaders. Evidently, there is some ongoing historic conflict between the Dalai Lama and the Panchen Lama, and the Chinese are using this fact to prop up the Panchen Lama. Though the political reasons are not obvious to us, the Panchen Lama must have made a pact with the Chinese occupiers that the Dalai Lama is unwilling to make, for the propaganda we hear suggests that the Chinese are attempting to enshrine the Panchen Lama as the puppet lama for all of Tibet. To those on the outside, however, the Panchen Lama remains only a pretender to the throne.

As we traverse the monastery grounds, we encounter a group of jostling novice monks, wearing red robes underneath gold cloaks and distinctive yellow and red cockscombs of the same wool material, with featherlike adornments as the crest of this well-worn regalia. All of the clothing seems in need of a thorough washing, and I suspect this is their entire wardrobe. The young boys are removed from their families as early as age eight and sent to the monastery to escape poverty and

Fortress of Gyantse, Tibet

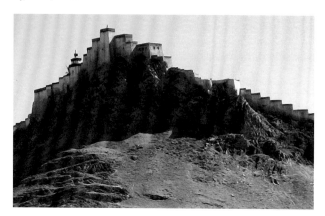

seek a better life. One smiles and poses at Kathryn's request, but they are far more interested in their own play and laughter than in two middle-aged tourists from another land. We watch as they take off their plumed golden hats and knee-high soft boots and run barefoot on the cold stone when called to the meeting hall by a ram's horn to recite and chant scripture. Inside the prayer hall, age equals rank, and they assemble accordingly, lowering themselves into the lotus position while swaying and chanting in cacophonous cadences.

The Tashilunpo Monastery is less crowded and more accessible than some other sacred sites, including the Potala, and thus one of the highlights of the trip. There is sometimes only limited access allowed in palaces, temples, and monasteries because of crowds or decaying conditions. In some places, like Gyantse, the buildings and treasures are deteriorating—wood is cracking, paint is chipping, frescoes are flaking—a process that is likely to continue unless there is outside help. Because of this, photos are sometimes only allowed on limited portions of the grounds, and almost always for a fee. To our immense good fortune, however, at this monastery we are allowed into the central hall, with a statue of Buddha at one side, the chant

Elderly monk, Shigatse Temple, Tibet

leader's throne at the front, and perhaps two dozen rows of benches where the adult monks sit. Moreover, for less than US $5 we are allowed to photograph the proceedings. The monk, upon receiving our payment for the privilege of taking a photo, tears a ticket from its roll, spits on it, then hands it to us. Bruce laughs, and a moist towelette is forthcoming from Kathryn. In Tibet, spitting is said to drive out the evil spirits.

We continue to observe as the monks are first fed their dinner, most of which is rice in a plastic bag, eating it with their fingers. The apprentice monks run from the kitchen adjacent to the central hall, bringing food to their elders. In contrast to Chinese Buddhists, who are vegetarian, we are told that Tibetan Buddhists also eat beef, mutton, and barley, the three treasures of Tibet, although today we see only rice. Kathryn's notes indicate that for Tibetan Buddhists to be allowed to eat meat, they are not permitted to see or hear the animals killed and the animals cannot be killed solely for them. Before the monks have time to finish, the leader, in a voice that approximates the low eerie octaves of a didgeridoo, begins chanting, and we are transfixed as the concordant contemplatives join in unison. The room is large, dark, and we stand on one side, where a ray of sunlight passes through at an angle, creating a mystical atmosphere. While we observe the monks, in a back room we catch a glimpse of Tibetan workers singing and dancing as they clean or repair the room, apparently energized by the spiritual practice.

For us, the chanting monks and locals singing or playing instruments are the most magical times of this journey, moments of cultural transcendence. While many come to China to see the Buddhas and the tombs, I am far more intrigued by the activities of local people, especially musicians. I am drawn to life, and life is the present: I seek the instrument makers, the yak noodle soup, and the slices of donkey.

Before we leave the monastery, Bruce points to a building about six stories high, informing us that, due to the altitude, it is the tallest building on the planet. So it was not surprising to find, upon arriving at our three-star, fourth-rate hotel, the Shigatse Shandong Mansion, a freezing lobby with three employees behind the desk wearing thick coats and gloves. In better times this nine-story hotel might have served a couple hundred guests, but tonight there is only our guide, our driver, and us. We stumble to the elevator, for other than a few lights over the shivering employees the passages are dark. We arrive in our nonsmoking room, but with every breath it seems a layer of smoke peels from the walls and enters my lungs. The bathroom toilet and tub are burgundy, the toilet wrapped with an unconvincing "sanitized" band; Kathryn is dubious and sprays disinfectant, to my approval. My sleep, punctuated by premature awakenings, is fitful. I lack the oxygen to fully hallucinate but for some reason must intermittently open my eyes to the darkness. We are in the highest city on earth—at 14,000 feet, 150 meters above Lhasa—and are breathing only 60 percent of the oxygen available at sea level.

MONDAY, NOVEMBER 2 ~ SHIGATSE–LHASA

We awaken early, are fed an untenable but generous breakfast of canned meats, pink sausages, a yogurt drink, toast, and other unremarkable items. Kathryn eats the yogurt; I have the cold toast. Bruce comes in, and two waitresses wearing heavy jackets serve him an entirely different breakfast of Chinese or Tibetan food.

We leave at 8:00 a.m., when it is still dark, and quickly exit Shigatse for the northern route back to Lhasa, via a narrower river valley than before. The roadway engineering is impressive; on the other side of the river lies a dirt road with occasional vehicles, and I imagine our side of the road was similar in times past. Befitting a nation with a surfeit of labor, in the Tibetan region we see roadside crews with crude wooden and straw brooms cleaning the highway. Prayer flags dot the landscape: on the tops of homes, in unlikely crevasses in the mountains, in random spots along roadsides, and draping electrical towers. Kathryn says the prayer flags sprout from hills like brightly colored flowers. In the changing light, the mountains, fields, and river valley blur into universal shades of brown and gray, punctuated by the river: fluvial olive, jade, turquoise, and tourmaline. Yaks, goats, and dogs are scattered like boulders and stones throughout the countryside. Fields and tree plantings adorn the valleys—an attempt to decrease the oxygen deficit. In some places double-yoked yak teams turn over fields with wooden plows. Many fields lie dormant, so animals are allowed into gardens to consume any remaining stubble. We pass tractor-taxis—

tractors hooked up to open carts that take passengers back and forth, nearly always carrying decorated Tibetan women on their way to and from towns. With weathered faces, they anxiously flag passing vehicles for rides. We also occasionally pass stores with signs advertising Coke, Sprite, and Budweiser.

Speed limits are enforced by monitoring times travelers pass through various checkpoints. Regularly, we stop for our permission papers at roadside police kiosks or stations, where we are given a sheet indicating the time we leave. In the event we arrive at the next station too early, the driver is fined. We have been told this practice resulted from truck drivers speeding down roads and highways, endangering the lives of people and livestock. To circumvent this restriction to the speed limit, our driver speeds down the road, and then we take random breaks to delay our arrival at checkpoints. One stop today is at the base of a celestial burial site. In contrast to the river burial site we previously visited, at the celestial burial site monks take remains to the top of the mountain, where there is a stupa, and perform the identical ritual of dismembering and disposing of the body, but with one compelling exception: the remains are left as a meal for vultures. We see a truck halfway up the mountain and two red-robed monks descending from the summit, indicating, to our relief, that we have missed our opportunity to witness a dismemberment.

In humorous contrast to this macabre scene, a busload of about ten Tibetan women descend from their vehicle, walk over to a nearby ditch, hike up their long skirts, and pee. I am reminded of a place where we stopped earlier.

A group of about eight, mostly children, one as young as four, were heading toward a temple in Lhasa, still more than 40 kilometers away, while prostrating themselves the entire way in an act of humility toward Buddha. They were traveling like inchworms, dirty in their robes, falling to their knees, extending on the ground on wooden hand skids, coming to their feet, and repeating this movement, mile after mile. One member of the group was traveling on a motorized bicycle cart with a bit of food and some tents as their only supplies.

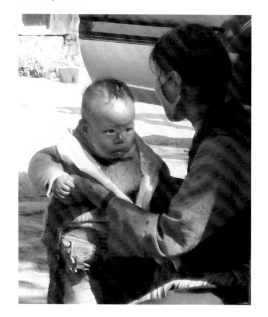

A smudge on the nose for good fortune, Lhasa

They took turns in oncoming traffic, a hand out for a donation. When we stopped, they signaled for something to drink, and we gave them a small donation and some leftover soda. As they went down the road, I felt compelled to follow. I gave them an additional bill, and they looked at me through grateful eyes, placing their hands toward me in devotion.

Now on our trip back to Lhasa, through the rear window I watch four young girls as they bounce a basketball, playing a universal game. Soon our attention is redirected to a band of gypsies coming down the road; to me they look filthy, and Bruce approaches them to give them a drink and a small amount of money. According to Bruce, long ago the tradition in Tibet was for a citizen to take three baths in their lifetime—when born, when married,

and upon death. With the water so cold and little fodder for heat, I can understand the aversion to bathing. Currently, there is a traditional bathing festival in September, as the water is clean and warmer in the late summer. For people heavily wrapped in robes, they paradoxically lack modesty, as the ritual bath is coed. Kathryn notes that at the late summer's bath, "some juvenile couples are said to disappear into the brush at the river's edge."

We are amused with forms of transportation powered by pedal or motor. In Shanghai, there are hundreds of bikes queued up at major intersections; their riders, following traffic rules we don't understand, occasionally get to use bike lanes. There are airplanes; overnight trains, seedy but workmanlike, such as the one we took to Turpan; and the Maglev seamlessly traveling at 450 kilometers per hour. Then there are motorized tricycles—some with an engine between the front wheel and an open belt connected to a driveshaft—tiny cars, tiny busses, regular sedans, Ferraris in the eastern wealthy cities, buses, trucks, tractors pulling carts, and wagons pulled by horses, donkeys, and yaks. Mechanical assemblages are of every description from the rickshaws in Beijing to the crude wooden slides used on the dunes in Dunhuang. And in one disappointing similarity between nations, drunk driving is often tolerated with the payment of a fine.

Upon our midday return to Lhasa we drive to the Sera Monastery, built in 1419, and walk down the pedestrian tree- and kiosk-lined avenue approaching it. Begging children with hands outstretched first plead for 3 yuan and bid

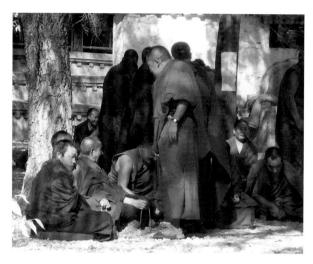
*Monks' debate,
Lhasa*

themselves down to 1 yuan before losing hope for profit; several dangle a crystal as barter for this exchange. I have culture fatigue and lag behind in spirit as we reach the grounds of the monastery. We are here for the afternoon monks' debate taking place in a courtyard, where novice monks are challenged by one another to demonstrate their levels of proficiency in Buddhist tenets. We watch the lively debate along with a couple of dozen tourists for about a half hour, observing how periodically one red-robed monk stands, confronts a seated companion, and claps loudly toward the student when given an answer, although we can't tell if the clap is an admonition or an endorsement.

After viewing the debate, we return to Dropenling to finalize shipping arrangements for our chest. We put the chest into the back of the shipping van and pile into the front, then our "Field Sales Executive," Mr. Tennor, Zha Xi, drives us to a two-story office courtyard about fifteen minutes away. The local DHL office is on the second floor of this building, seemingly a faux pas of corporate planning, requiring customers to carry their items upstairs to the shipping company. The DHL assistant calculates the charges and informs

us it will cost US $700 to ship the chest home. We gasp at this information, then fork over our credit card and accept our destiny. Additionally, Mr. Tennor, Zha Xi, then tells us he will need to build an aluminum box in which to ship the chest safely, which fortunately will cost a reasonable US $25. Ultimately, when the chest arrives in the United States we discover a perfect use for the aluminum box—storing firewood in the garage.

The Pomp of Beijing
and a Visit to the Hospital

TUESDAY, NOVEMBER 3 ~ LHASA–BEIJING

We leave Lhasa around noon on Air China flight 4111, heading back over the same river plain where now it seems dragons have flown, their trailing talons creating river channels. The tapestry of Tibet has been colorful, offbeat, awe inspiring; yet the restrooms at the new Lhasa airport reek of yak piss, something we are glad to leave behind. We ascend, and below us is a broad, rugged coffee-chocolate mountain range, with peaks like the spines of ten thousand inert dinosaurs dissolving into the horizon. In the distance are sun-drenched white peaks, and I dream that one is Everest. I see clouds simultaneously forming and disappearing—a phenomenon, we are told, that occurs as a result of evaporation.

We fly from Lhasa to Chengdu and then to Beijing. On our flights there are four or five other Caucasians, a monk with a cell phone, the usual decorated military men scattered throughout the plane, and other passengers snoring. On the airline's TV, I watch a parade in celebration of the sixtieth anniversary of the revolution. A throng of people form a Chinese flag, then a large banner of Mao; rockets are rolled on wagons, along with an astronaut, dragon floats, silly cartoon characters, and large banners of self-absorbed dignitaries—the usual nausea of pageantry. As we near our intermediate stopover in Chengdu, the mountain valleys below are filled with rippled bowls of clouds. In a childlike fantasy I imagine a soft and joyous landing into this mirage.

On our later flight to Beijing, I reflect on some aspects of our journey so far. I feel pride at having undertaken this adventure, which necessitates fortitude, flexibility, and stamina. We find that though arduous travel may be an aphrodisiac for the mind, our physical strength is spent on the days' excursions.

On this trip, flying and riding in vans has become a way of life. The airlines we have flown on have included American, China Air, China Southern, Air China, Sichuan. The vans used for our tours have been functional and nondescript; I usually sit in the back row for greater legroom and because I tire of the guides' stories, while Kathryn enjoys recording the facts they recite. On flights, I try to find an empty row so we might have breathing room, and I have been successful on a couple of occasions, making it easier for me to write. My notes have become difficult to decipher, as they have often been

written in the back of jolting vans on the road or while descending 35,000 feet through clouds.

Doing laundry has become an everyday event. When we arrive at hotels, we begin our ritual of bathing and washing clothes. At some stops we send our laundry out, mainly jeans since they are difficult to dry in hotel rooms. Fortunately, hand laundering is made easier by our imperative to pack clothes that will dry quickly, usually those made of polyester, including short-sleeved shirts, long-sleeved shirts, pants, and underwear. Other items packed include wool socks, one fleece jacket, one windbreaker, a pair of gloves, and a sun hat. Underwear frequently decorates our bathrooms like prayer flags—though far less colorful.

WEDNESDAY, NOVEMBER 4 ~ BEIJING

In Beijing, I open my eyes in the five-star Sunworld Dynasty Hotel to a view of a large open pit of rubble across the street, fronted by small shops topped with billboards. The heat in the room cooked us slowly through the night as the thermostat is apparently defective, and we slept fitfully. I take a cold bath, while Kathryn coughs intermittently, her sinus problem flaring. I take her temperature with the thermometer from bedside kit, which includes "Strong Man" condoms and the phrase "Love. Life. Refuse. Aids."—seemingly more useful than a Gideon's Bible.

We visit Tiananmen Square and the Forbidden City. Tiananmen Square is vast, supposedly the largest public gathering space in the world. Meaning

"Gates of Heavenly Peace" in Chinese, it is a new creation as China traditionally did not have large public gathering areas, and walls of the Forbidden City were razed to create the square. Tiananmen Square is flanked by the Great Hall of the People on one side—now an exclusive club at which attendance of the "ordinary" is restricted to three days each year—Mao's mausoleum on another, the National Museum of China on the third, and on the fourth Tiananmen Gate, with its ancient viewing pagoda previously restricted to the emperor and now used by dignitaries during pretentious ceremonial occasions. Mao's mausoleum is a massive structure where older Chinese are queued to pay their respects. We decline this honor.

At Tiananmen Square we are in a circus of humanity: thousands of Chinese divided into tour groups of twenty or forty each, with matching T-shirts or baseball caps, marshaled by guides armed with portable loudspeakers; foreigners of every persuasion; hawkers pushing books about Tiananmen and the Forbidden City; and kite sellers. Large, brightly decorated poles line each side and a banner portraying Mao hangs below the viewing stand. Uninspired by the vanity and egoism it reflects, I can't help thinking the cult of Mao is yet another in a long history of Chinese dynasties. At the same time, I

Forbidden City, Beijing

feel a certain awe, as I have felt in Washington and Moscow.

We wander through a subterranean tunnel to the Forbidden City, so named because it was off limits to commoners. Amidst the crowds, it feels as if we are teeming like bacteria in the throng of humanity. The Forbidden City is separated from Tiananmen Square by a series

Military training, Forbidden City, Beijing

of about eight huge linear courtyards, each with a different function, that seem to stretch for a mile before dissipating into a park. This is the largest human structure I have seen, with its myriad walls, massive elaborately adorned palaces, towers, gates, and thrones. Stunned by its scale, I become bored with its details. Kathryn notes: "There are elaborately decorated, gold-studded doors against a background of red lions gripping balls between clenched teeth...buildings with dragons chasing several other mythical animals...a rooster as a drainage spout, made of green porcelain. Blue and white Ming vases adorn many of the rooms. There is a calligraphy room and a concubine quarter, where girls are kept when they are between the ages of eight and thirteen...the emperor has his way with them and then decides who he wants to be the empress. She receives a scepter encrusted with gems, while the runners-up get silk purses. (What a prize from a royal swine.) The center door of each structure is reserved for the emperor only."

Emperors' incense-burning lion, Forbidden City, Beijing

Tonight we have a dinner of Peking roast duck (which is actually inferior to my mother's roast duck), with thin pancakes, plum sauce, sliced cucumbers and scallions; bean curd skin, which arrives in a soup bowl accompanied by tripe; and a red pepper, broccoli, and beef dish. Our guide Edward and our driver join us, and Edward later shares his disgust that our plump driver "only wants money" and is "crude." Edward implores us not to tip the driver, and the next day the driver is replaced. Following our meal, Kathryn and I shop for water and are interrupted by a young couple who claim to be students of calligraphy wanting to practice English. After talking together for about five minutes, they invite us down the street to their school so they can write our names as a gift. I whisper to Kathryn, "Scam!" and we walk away rapidly, unwilling to repeat our Shanghai "teahouse" escapade or, worse, get drugged or robbed.

Back at our hotel, a protest related to employment further underscores the poverty of the people and the actions necessary to maintain a livelihood. In the parking garage, a line of hotel employees surrounds about forty men who are sitting in a group eating and drinking. Soon families join the men, and a woman, perhaps one of their wives, makes an impassioned speech. We find

out that the seated men are construction laborers who worked on the hotel but have not been paid; that frequently payments are made annually; and that workers often have to demonstrate to be paid. The hotel managers, obviously embarrassed, restrict access to the garage, which becomes filled with wrappers and blankets after a couple of days. The police at the site seem uninterested in getting involved in the dispute. Finally, we come down one morning to discover that the episode has reached a resolution as the strike camp has become a ghost town.

In another incident related to work conditions, we talk to a man whose mother is chronically ill with some condition connected to her blood. He says that years ago she worked in a factory and was forced to donate blood or be fired from her job and is convinced that the repeated demands for blood ruined her health.

THURSDAY, NOVEMBER 5 ~ BEIJING

We phone Edward early in the morning to tell him that because Kathryn's ear is congested, we need to see a doctor and that our room is unbearably hot. He arranges for an upgrade to a suite with a functioning thermostat and then takes us to the central hospital in Beijing, the Xie He Hospital. We are told it was built for Western medicine, and it resembles such a hospital architectur- ally—imposing and dull, with lots of polished linoleum. The hospital, which also functions as a clinic, is superfilled with people, as I imagine the inside of

a hive is with swarming bees. Most patients and personnel wear blue medical masks to filter the air against such offenders as sulfuric fumes and swine flu. I strap on a mask but fear its protection is insufficient. There is scant privacy, with many people being examined in open cubicles. The doctor, seemingly a nice man though he does not appear at first to speak English, examines Kathryn in a private room labeled "Ear, Nose, and Throat" opposite two rooms marked "Massage" and "Acupuncture."

The doctor then sends Kathryn to the next building for a hearing examination, and a hospital guide helps us navigate the crowds. Upon her return to the doctor, it is confirmed that Kathryn has fluid in her middle ear, and she is given five prescriptions. We go to the payment window, as advance payment is required, then head to the pharmacy, where Kathryn is handed two packages, two nondescript bottles, and a nose spray. We return to the payment window and are refunded RMB 5, or about US 75¢. We have spent less than US $100 on the doctor, the audiology testing, and the five prescriptions.

Relieved to have Kathryn's treatment, we head to lunch at a lively restaurant, the Temple of Heaven. Upon entering, we pass a boa constrictor in an aquarium and wonder whether this is a delicacy. Reviewing the menu, I see the following intriguing offerings: steamed cattle lung Beijing style; pork tripe and pork intestine in casserole; sweetened white fungus soup with lotus seeds; steamed mutton spine; San-Yan ox skull; and honeydew dates with osmanthus flowers. I find no coconspirators for the mutton spine.

We spend the late afternoon exploring the back paths of the Temple of Heaven, aware that magic can occur with a chance encounter. Sure enough, we come upon a man with a back satchel, later learning he is seventy-six years old. The man shares with us that he has visited Los Angeles, San Diego, Washington, DC, New York, and San Francisco. Kathryn's attention is riveted on the satchel's belongings. As Edward interprets, the man gently pulls out sections of a breathtaking kite in the shape of an eagle or hawk, a somewhat worn, honored, and priceless relic he created twenty years ago. He assembles it, and we are astonished that the wingspan is at least four feet. Then he hands it to me, and I fear holding his treasure as I would be aghast at damaging his artwork. He agrees to pose for a photo with us holding his masterpiece. He takes his wooden spool, about 14 inches in diameter, which, as Kathryn notes, resembles a miniature ship's wheel, and walks about 100 feet away, where he flies his creation as skilled as any aviator. We watch in awe during a rare tranquil moment on the grounds of this palace in Beijing.

As we leave the park, we pass a mesmerizing quartet of musicians. They are older men, with lutelike instruments and a flute of a dozen bamboo pipes, accompanied by a woman singing. A little further on we come across a coterie of folks dancing to Chinese Klezmer music. I join in and dance opposite a Chinese man, both of us laughing and pleased. He entreats me to stay, but we take our leave, with joy at having participated in this ephemeral frolic.

We return to our hotel room, this one on the top floor of the Sunworld Dynasty, where we are greeted by a new friend—"Toto," a space-age alligator-mouthed lavatory, whose jaws oscillate unnervingly each time we walk by and often according to its own whim. Perhaps even more unsettling are the operating options: "Rear cleansing"; "Rear cleansing soft"; Front cleansing"; "Dryer"; "Oscillating"; "Pulsating"; and "Rinse cycle." Also Toto's lower jaws are heated, and I am chagrined at the thought of them having heated another person's backside. I am afraid to consider my options, and do my best to ignore our new pet as long as possible.

FRIDAY, NOVEMBER 6 ~ BEIJING

A headline on the front page of yesterday's *China Daily* catches my attention: "Olympic Condoms under the Hammer." The article says that the proud owner of 5,000 unused condoms remaining from the 100,000 distributed to the participants in the 2008 Beijing Olympics are to be auctioned off. The minimum price is 1 yuan, or US 15¢, and the buyer is obliged to purchase them all. With 95,000 having been used, it sounds like the real Olympics were held undercover.

This evening, as I work on the Internet, Kathryn goes to the grocery store at Edward's urging so we can avoid eating in a restaurant. They return with pears, bananas, almonds, and a chicken replete with head and feet. As I am a savorist with a faint recollection of having once seen my father eat a meal containing chicken feet, I try it and find the skin and cartilage of the feet intriguing

but discard the head, nevertheless reveling in the adventure. We note that chicken bones seem to be crushed rather than cut in many Chinese dishes.

Later, as we gain courage, we decide to investigate the wonders of Toto, and Kathryn relates that she feels she has made a pit stop at the Bottom Beauty Salon. I assure her I have no intention of duplicating Henry Miller's culinary experiences in *Quiet Days in Clichy*.

Birdcages and a Birthday Squid in Hong Kong

SATURDAY, NOVEMBER 7 ~ BEIJING

We are exhausted. Kathryn's rasping the last two nights has worried me; the first night I tended her, but last night I took an Ambien as I had a fever, though mild, and thankfully slept through the night.

Come morning, we tour the Great Wall at its closest and most congested location, Badaling. I pride myself on my conditioning; back home, at an altitude of 7,000 feet, I jump rope on the gym's trampoline. But at the Great Wall, after we climb for only fifteen minutes my breathing feels like icicles piercing my lungs, and I go no further. To her credit, Kathryn continues upward with Edward for a reasonable but seemingly endless evaluation. I am left alone writing, while others unendingly dart and amble by like schools of minnows

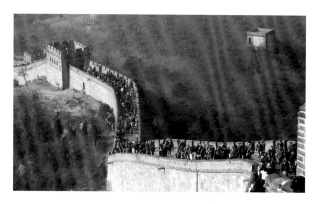

*Great Wall
at Badaling*

in an ocean of humanity. Their shutters click as the ladies carefully pose while the men smile. Occasionally a Chinese tourist in a black-and-white panda cap with fluffy earmuffs passes by giggling. A man leans next to me, clears his throat, and spits—throat clearing and spitting being a national pastime. And as I observe the earth dissected by this wall, I wonder at the natural disaster it created for migrating creatures.

When Kathryn descends, we set out for our Great Wall Tourist Buffet, which is mediocre and forgettable, then we return to the hospital. This time we are both treated: Kathryn's medicine is adjusted, and I am prescribed an antibiotic and root-colored cough syrup before returning to our room.

SUNDAY, NOVEMBER 8 ~ BEIJING–HONG KONG

Sunday morning I leave Kathryn, who is in no shape for an outing, and go with Edward to the music district of Beijing in search of a stringed instrument I identified on the grounds of the Temple of Heaven. We visit at least fifteen shops, some exhibiting exclusively guitars while others having guitars and Chinese stringed instruments, some violins, and wonderful horizontal Chinese harps. I am fascinated by the harps but want something more manageable and

playable, focusing on a *daruan*, or *ruan*, a four-stringed lute of high quality and resonance. I settle on a price for the lute, then I try many gongs and select a large one before realizing that transporting it is beyond my means and instead settle on a smaller one, eighteen inches in diameter, whose resonance would fill a stadium. Edward finalizes the transaction, and I leave content. While carrying the instruments up to our hotel room, I fear the airline will reject my carry-on bags when we fly out that afternoon, only to learn that Hong Kong Express will indeed allow us on with them.

Our scheduled itinerary has ended, and Kathryn has chosen to spend our final ten days in Hong Kong. We look forward to a respite, as for twenty-one days we have followed a rigorous though illuminating itinerary. We have been spun like tops and have found our immersion in Chinese culture profound though taxing. We have been to the far side of Pluto. My wanderlust for the Chinese mainland has dissipated. I think to myself that perhaps Tibet represents the past, the Chinese mainland the messy present, and Hong Kong the elusive future.

The Great Wall

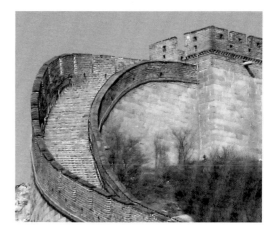

Edward, in his usual overprotectiveness, has made sure we are at the airport three hours early. We stop at a guard post, where we are checked and allowed into the international waiting area. One quirk of the Beijing airport is that there are

no permanent airline desks and no services other than a water fountain and clean restrooms. Only two hours before a flight do desks open up in the five or six rows of check-in counters. Also, whereas in the United States at almost any major airport there are flights every minute, in Beijing there are just a couple of international flights each hour and about the same number of domestic flights. I study the destinations in the international terminal—Moscow, Ho Chi Minh City, Hong Kong, Seoul, Amsterdam, Seattle, Dubai, Kuala Lumpur, Novosibirsk, Addas Adeba, Brussels, and Lagos. When the Hong Kong Airlines flight lights up, we head to the front of the business line to buy an upgrade as we long for pampering, but they refuse to comply as it requires additional approvals. The woman who refuses us the upgrade, however, being far from the ogre I have imagined, offers us the exit row, affording us extra legroom.

Following takeoff, we notice immediate differences compared with our other flights in China. The young man seated on our window is Caucasian. Also, one-third of the passengers are coughing or sneezing even though we have left behind the pollution that created a constant haze in the atmosphere. Although I have a strange feeling that this germ-plagued fuselage may be the purest air we've ingested in days, the continuing chorus of coughs indicates the percentage of passengers who may not be disclosing their true condition on their health forms. I admit we are among the miscreants, though we have been assured at the hospital that we do not have the dreaded flu. I think back on the previous night's room service, and want to reassure my mother that we

had healing wonton soup with delicate shrimp dumplings, almost as tasty as her chicken soup and kreplach.

We arrive at Hong Kong airport and are not quarantined, though we have been told there are overhead sensors that magically detect a fever as people cross underneath. We grab something to eat at a Burger King, a poor substitute for food, take the train to the city, and then, near midnight, catch a cab to the wrong hotel—the Langham instead of the Langham Place. Frustrated, we requisition another red and white taxi, which finally takes us to our destination, where we are to meet our friends Alfredo and Elena, the preeminent flip-flop wholesalers of Puerto Rico who have come here on buying trips annually for two decades and who recently bought a house in Santa Fe.

Once in our room at the Langham Place, Kathryn peruses magazines, brochures, and hotel information. I am aware of this tendency, and when she does it at home I often make a sarcastic comment. But tonight she finds a gem as the Hong Kong Visitors Kit contains the following ad for a restaurant, particularly ironic in light of our past month:

MODERN TOILET

We introduce toilet into dining, and idea of "Food+Toilet" concept breaking through the traditional way of dining. Chairs are made of toilet bowls. Food is served in mini toilet bowls. Bath tubs, washing basins and urinals! Enjoy your meal in toilet.

The accompanying graphics show chocolate yogurt served in a commode, and to my surprise I find the ambitious chain has two locations. On this amusing note, we shower and go to bed.

The next morning we awake still tired. Alfredo and Elena, who are here for this one day and leave for Bhutan and Nepal tomorrow, graciously wait until we are ready and then guide us to Stanley Market. They teach us how to use the subway, aptly named the "Octopus," and accompany us on a double-decker bus. Kathryn's ears act up, and later I get a fever, but we are not willing to miss the day with our friends.

Alfredo also gives us more information about the area surrounding our hotel. The Langham Place is in Mong Kok, which Alfredo says is the most densely populated area in the world. Here there are Chinese, Filipinos, students, tourists, British, and a couple of Puerto Rican wholesalers of beach sandals. As we climb the steps to the pedestrian walkway overhead that crisscrosses the city, we notice some Filipino day laborers have set up a cardboard tent camp on either side of the walkway. They have been imported to do housework, and Sunday is when they can socialize. Occasionally I catch the furtive stares of women desperate for something, but I have nothing to give them and feel ill at ease in this gauntlet of anxiety. Alfredo tells me that however poor and badly paid they are, Indonesians are now being imported as they will work for even less. My guess is that the mainland Chinese are willing to come but that there are restrictions on migration from the mainland to

Hong Kong. In any case, I don't believe that Hong Kong can handle another billion people.

Reflecting further on population changes in China, I have learned that because of the current system men far outnumber women—1.25 men for every woman. One reason for this is the one-child policy currently in place to limit population. Another reason is that the Chinese culture has a long-standing preference for male children, partly because married daughters live with the husband's family while married sons stay and take care of the parents in their old age. In addition, in a system offering no Social Security the only security for some people is having sons. Also, in an ancient culture of small farms sons are expected to assist in the family farming, though based on casual observation no one is exempt from field duty.

Since men now far outnumber women, women have become more discriminating in a choosing a mate. One young man lamented that a woman wouldn't pay attention to a young man without a car and a home, a frustration for most working young men. Nevertheless, in this country of more than 1.2 billion people we constantly see evidence of weddings, from couples having wedding portraits taken in customary venues to lines of limousines decorated, honking, and circling the streets. It appears that being a wedding planner would be a lucrative career in China.

In another confusing twist of fate, the one-child policy seems to apply chiefly to the Han in large cities. Minorities, like the Uighurs and farmers, who may or may not be Han, are allowed two children, perhaps because the

needs of rural life supersede those for reducing the urban population. Further, it seems ironic that in mainland China birth control is not only encouraged but the law, while in the United States religious zealots use draconian measures and sometimes violence to impose their personal beliefs. Also, it seems peculiar that the Chinese government continues its dominion over its minorities while allowing them superior rights in terms of procreation.

As for gay rights, lagging about thirty years behind the United States, young people have begun to create openings in the larger cities. In a society dominated by an obsession on having one child, and with a preference for a male child, the gay paradigm seems doomed to difficulty.

In trying to evaluate China's shifting population, I think back to the History Museum in Urumqi, with exhibits showing the colorful wardrobes and lifestyles of the Qie, Tajiks, Uighurs, Kyrgyzs, Kazaks, and twenty other minority cultures in this country now dominated by the Han. It seems clear that China's governmental policies will diminish the size and influence of these ethnic groups in the coming decades. Already the children of nomadic peoples are summoned away from their families for schooling, and these regions, as well as those of other minority cultures, are being repopulated with Han. One fascinating heirloom in the History Museum in Urumqi that underscores the value of preserving such minority cultures is a thick string hung high inside a yurt illustrating a family history through carved wood, metal, and bone icons. It represents a timeline symbolizing major cultural events and turning points.

TUESDAY, NOVEMBER 10 ~ HONG KONG

After our Sunday tour with Alfredo and Elena, we lay low for a few days. Room service has been our dining venue of choice, and French toast with maple syrup and fresh fruit my preferred delicacy. We watch TV, and to my amazement there is a travel show on exotic destinations highlighting South Congress Avenue in Austin, Texas, my home for thirty years, even showing the airstream trailer down the street from the area my partner Abe and I redeveloped and renamed SoCo at a time when the area was overridden with drugs and prostitutes. Jokingly I question whether the transition to yuppies is an improvement.

On Tuesday afternoon we explore the Mong Kok area. There is a dizzying array of people, shops, restaurants, banks, and colorful street vendors. The streets of Hong Kong are ground zero for the world's curios, bric-a-brac, and cheap garments. One street over we find blocks of canvas stalls in rows selling T-shirts decorated with every incarnation of dragon and the words *Hong Kong*; purses; tacky nurses' and maids' costumes for the bedroom, along with men's underwear made to look like an elephant's nose in 3-D; belts; tchotchkes; and silk pouches. On some nearby lanes, we see the following advertisements: "Luxurious Hotel Facilities Hourly. Special Prices for Overnight"; "For Two Hours"; the "Spanish Hourly Hotel"; and the "Virginia Hourly Hotel." Meanwhile, 7-Eleven, which punctuates the Hong Kong landscape as visibly as Starbucks in Manhattan, may have surrendered its

US monopoly to Indian and Pakistani operators but seems to have found a home in Hong Kong.

Had we visited Hong Kong before mainland China, I am certain I would have found the territory exotic. But after camel rides, live baby catfish hot pot, and celestial burials, experiencing Hong Kong tailors and a clean subway is almost like being in a Western city. Hong Kong seems a melting pot of the East and West, eastern China a fledgling West, and western China and Tibet a primordial genesis.

Back in our room, I lie naked in the bathtub, which has become a porcelain workplace. I reflect on the healthcare bill just passed by US House of Representatives. Part of a transformative and sometimes self-righteous mindset that prefers acupuncture, massage, organic food, and Eastern approaches to health, we are happy to have missed the debate, particularly the selfish attempts by the drug and insurance industries to derail a decent solution to a major problem in our country.

Comparing Eastern and Western perspectives, I try to identify the best and worst things the West, primarily the United States, has introduced to the East, coming up with the following. The best: commitments to freedom and democracy; creativity and innovation (except for putting wheels and motors on crates and bicycles); the first amendment; Michael Jackson, who currently symbolizes our country in China, where people stand riveted to TVs outside appliance shops watching him dance; Hollywood and the NBA; Pepto-Bismol;

industrial farming of trees, for which I have no social conscience after searching for scraps of toilet paper in a country lacking sinks and soap; electing Obama, which proves right-wing fear mongering has its limits; Calvin Klein underwear, as most of us would rather look like the hunks and beauties on the posters in the mall than the guys with the funny elephant-nose briefs. The worst: Coca-Cola, a chemical and sugar nightmare for

Junk in Hong Kong Harbor

the body, though, when traveling, I confess to occasionally breaking my rule of not drinking it; Burger King; obesity, which became clear upon hearing our shills in Shanghai express surprise that we were American but not fat; smoke, as we led in tobacco use, then in pollution, though the Chinese have now surpassed us in both.

WEDNESDAY, NOVEMBER 11 ~ HONG KONG

Today we shop, spending a couple of hours at Shanghai Tang, a store like Neiman Marcus or Saks, where prices are attached to goods and negotiation is taboo. We spend a small fortune on three purses. Kathryn offers to buy me a sweater that costs over US $500 as a birthday present, but I refuse.

In another shop, Kathryn asks a Chinese salesperson for directions to a store mentioned by Elena. Soon three women are busy in a song of solution,

and I realize there is something universal about the camaraderie of women joined together to help another woman find a shopping destination—somewhat like the camaraderie that might ensue if I asked a stranger in a Pittsburgh Steelers jacket who won a particular game.

THURSDAY, NOVEMBER 12 ~ HONG KONG

The local newspapers frequently provide me with additional insights about the politics and culture of China. Relegated to page seven of the November 12, 2009, *South China Morning Post*, hung on the door of our luxury room overlooking the Kowloon skyline, is the article "Shenzen Petitioners May Be Sent to Labor Camps." The new rules "target those who make 'abnormal' petitions or requests." Those recorded twice would be given a verbal warning; those with a verbal warning would be detained if they made a third "abnormal complaint"; and those who have been detained would be sent to a labor camp for up to three years if they made a fourth. Offenses include traveling to Beijing and petitioning in sensitive areas, protesting in the city center without official approval, and chanting slogans or distributing printed materials. One man, who had the courage to be named and was looking for answers, said, "It won't scare me, as I already have nothing. Why do we petition frequently? Because authorities misconduct themselves and ignore our pain. Why don't they try to help us, instead of ignoring us?" Gulag, anyone?

An illuminating article from the November 2, 2009, *China Daily*, prompts me to reflect on science and politics. The article reported the death of Qian Xue-sen, the father of China's space program and one of the most influential and accomplished Chinese scientists. Qian received an aeronautical engineering degree from MIT in 1935; a doctorate in Aviation and Mathematics at Caltech in 1939, where in 1943 he cofounded the Jet Propulsion Laboratory; and in 1947 became a professor at MIT. Imprisoned for fifteen days in 1950 then placed under house arrest for five years during the McCarthy era, he returned to China and established the Chinese space program. So in a strange twist, the xenophobia of America in the early 1950s resulted in the defection of one of our foremost scientists, ultimately to the benefit of one of our leading competitors.

Another article in the *South China Morning Post* reports that "Dozens of the mainland's increasingly assertive journalists have been beaten, detained, or sued in the past two years…" It goes on to say, "Of the 33 cases mentioned, almost all involve journalists being beaten." Reporters have been threatened, roughed up, and slapped with false criminal charges. A different article refers to the "black jails," which are informal detention centers where the government locks up those who complain, especially stifling voices during showtime for the party. The paper also reports on the citizen dissident Feng Zhenghu, who has been traveling and is not allowed back into the country; having been turned away at the Shanghai airport eight times since April 1, he has been living in a Japanese airport for nine days.

FRIDAY, NOVEMBER 13 ~ HONG KONG

With trepidation and optimism we board the subway, and after our first couple of rides feel like old-timers. Our concierge has sent us to a tailor at the Peninsula Hotel, where the offerings are outstanding but the prices prohibitive. We follow the map to Mody Road and browse through the half dozen or so tailors until we choose one. Here we meet Mike, our personal sales representative, who is extremely farsighted and bumbles through the reams of samples. His business card has printed in bold red letters: "Beware of Street Touts"—a good warning, for when exiting the subway at the nearby station we are accosted a number of times. I am more accustomed to ready-to-wear, having grown up selling jeans and western shirts in my father's dry goods store, but though we are insecure about the process we have faith in its ultimate success. We return for fittings and are ultimately very satisfied with our choices. Kathryn has one silk and one

Searching for silk fabric, Hong Kong

wool suit made, while I have a knee-length black Scottish cashmere overcoat made, as well as a silk and cashmere sportcoat, shirts, and cotton slacks. I even have them make a white guayabera, a Mexican-style shirt, this one designed by an American (me), sold by an Indian, and made by a Chinese.

Afterward, we head to Bowring Street, an avenue of small shops, where a tent city of

vendors supplants the forbidden traffic. Kathryn is intent on finding a specific silk fabric to cover a comforter; unsure why a comforter needs a cover, I have little hope for our success. To my surprise, we enter a nondescript shop, Manson Silk Co., with bolts of cloth like the pipes of an organ, locate the exact fabric, and find that the shop owner is knowledgeable and speaks English. We assure him we will return the next day as we have left the swatches and dimensions in our room. When we do return, he measures the cloth by holding it to his chin and stretching it out at arm's length. We return on a third day as Kathryn has decided that she would like a dress made from the identical fabric. I tease that she will disappear when lying on top of our bed.

SUNDAY, NOVEMBER 15 ~ HONG KONG

We begin the morning with a walk to the goldfish market, on a busy street lined with pet shops. The stores are small with troughs of koi, goldfish, baby turtles, fish food, aquariums, and aquarium plants. As it is Sunday, there are many locals—singles, couples, and grandparents with grandchildren—trading for small colorful pieces of life to enhance tiny apartments otherwise disconnected from nature.

We continue across Prince Edward Road and find the flower market, a row of shops across from a large berm. Kathryn is enamored of the vast array of orchids and a group of hanging vines and drooping flowers shaped like the nests of canyon wrens, but I quickly find the flower market redundant.

We continue on to the bird market, which we find the most fascinating, for the vendors sell not only birds of all sorts—budgies, finches, parrots, cockatiels—but also bamboo and metal cages, and even hutches of live crickets. Some older men, having carried their birdcages from home, meet to socialize and admire each other's feathered companions. The cages are covered with white tailor-made canvas, which they remove upon arriving. As we leave, we notice one of the garbage cans is marked: "For the disposal of dead birds only."

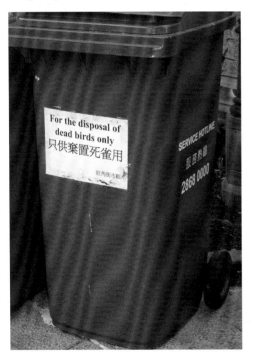

Bird disposal, Hong Kong

After leaving the bird market, we explore a meat market we passed before visiting the goldfish market. The first floor consists of seafood: fish, shrimp, clams, mussels, oysters, snails, bound hairy crabs, and eels. We see an eel sliced in half, the front section swimming in a shallow pool of its own blood. On another aisle we see dried fish of all sorts, which do not seem tempting. We climb the stairs to the second floor, where we are greeted by chunks of pork hanging virtually in our faces, along with pork vendors. As we pass through their aisle, the soles of our shoes are slickened by pig renderings. We explore the stalls with hearts, lungs,

snouts, livers, beeves, chickens, and ducks. Fans are poised to blow away the stench or flies, but are motionless today as the weather has cooled somewhat. We climb to the fourth floor rooftop restaurants, consisting of three or four open booths without menus, where locals are eating. Owners coax us to join them, but we are beyond our comfort zone.

Celebrating a birthday with chicken feet, Hong Kong

We head back toward the Langham Place searching for a suitable eatery for my birthday lunch. We decide that while we may have removed ourselves from external adventure, we can still create adventure at our luncheon table. We stop at the Vietnam Garden, a typical hole in the wall, and order oxtail soup, a whole squid stuffed with rice pilaf and baby shrimp, sautéed bok choy with garlic, cold chicken feet with sweet and sour sauce, and a soft-shelled crab. The owner comes over to confirm our order, saying that most Westerners don't order chicken feet. I am proud to announce that indeed I will be eating chicken feet, although Kathryn will not be indulging. When I dig into the cold chicken feet, I again find the cartilage interesting, though on the whole the fare is average. Upon returning to our room, we are surprised by a birthday cake, compliments of the hotel, surrounded by raspberries and blueberries and topped with triangles of dark and white chocolate, creating an unruly but delicious coiffure.

MONDAY, NOVEMBER 16 ~ HONG KONG

In Mong Kok, there is a gleaming mall adjacent to our hotel. At the lowest of basement levels, we frequent the grocery store; in the intermediate levels there is a hodgepodge of retailers and food vendors from H&M and Starbucks to an Asian food court. The array of escalators looks like it was designed by M.C. Escher, although during our ten-day stay my well-honed sense of direction is erratic but remains fundamentally intact. There is a lady with a cloth rag and a pail of indeterminate liquid whose job is to maintain contact between the rag and the escalator's rails, seemingly to disinfect them, and I am hopeful though dubious about her success.

Soho offers a welcome variety of restaurants and nightlife. To get there, we take the subway to Central and then walk to the outdoor mid-level escalator, which lifts us from street to street, an ingenious solution in a neighborhood built on steep hills like San Francisco. It seems like the place where young expatriates working in Hong Kong go to socialize, with bars open to our covered escalator. We have three world-class meals there, including a wonderful Italian dinner to celebrate my fifty-eighth birthday; a Nepalese spread; and a Mediterranean feast featuring the best lamb I've ever eaten, a loin. I ask about it and am invited into the kitchen to see how it is prepared. We chat with fellow Westerners and sometimes gloat over our adventures. On our last night, which is cool and rainy, we make a dash for the Tsim Sha Tsui ferry and take a romantic cruise across Hong Kong bay.

Though tame by the standards of Kashgar or Tibet, Hong Kong has been a delightful and welcome respite on our way home. We have gone from witnessing celestial burial sites to ordering tailor-made shirts, from eating donkey to eating dim sum, from riding camels to riding subways, from being in a military state to exploring a world economic capital. We have seen tyranny and experienced censorship. During the trip, we marked our first wedding anniversary and my fifty-eighth birthday. We have learned an immense amount and traded goodwill with our Chinese friends. We look forward to the comforts of home while knowing our departure from the many facets of China may well be a letdown.

* * *

THURSDAY, DECEMBER 24 ~ SANTA FE

At home, our days are permeated with a synthesis of joint memories and individual recollections. We reflect on how throughout China, including Tibet, there seem to be two dominant religions: Buddhism and growth. It feels as if the Chinese are at war to build their country, as evidenced by the scrabble and smoke that permeate every landscape and the uniform gray box homes in small clusters along main roadsides, indistinguishable except for their lovely painted doors. A nation on the run has little time for charm; the housing in many places is architecturally insignificant and seems poorly constructed in

favor of the imperative of growth. In a strange juxtaposition, the country that sweeps roads pristine is covered with thousands of piles of debris from construction and mining. In contrast, some commercial buildings in the larger cities introduce world-class architecture, causing travelers who never leave the large cities to hold impressions that diverge from ours. I arrive at an alarming insight: the Chinese government is spending wealth earned from the West to rapidly modernize their country, trading cheap labor and environmental disgrace for Western technology and Cokes.

The phone rings. It is Edward calling from Beijing to tell us he misses us and to share Christmas Eve greetings. Kathryn tries to explain that we are Jewish, but in the end we swell with joy that Santa arrived in the form of a thirty-three-year-old Chinese man who has taken to us as we have to him. Edward highlights my contrasting feelings regarding people and governments—that most people are curious and welcoming, while governments often have nefarious agendas. I recall the military convoys we witnessed and the communication curtailments. Smiling, I am also reminded of the warning of Confucius 2,500 years ago: "An oppressive government is fiercer and more to be feared than a tiger."

FRIDAY, DECEMBER 25 ~ SANTA FE

On this Christmas Day, when many Americans are celebrating a religious and cultural tradition, I reflect on my fascination with and admiration for the

Uighurs, and hope they can maintain their uniqueness and culture. Their plight is no longer abstract: I have walked their streets, eaten their donkey, and played one of their stringed rewaps at home. And so I am angered when I read today that China has strong-armed Cambodia into repatriating twenty Uighur asylum seekers for trial, over the objections of the UN and the United States. I fear these individuals will be executed, and though the United States has voiced its concern with Cambodia, the $4.3 billion that China has spent to build the infrastructure of Cambodia, including $1 billion on December 21, two days after Cambodia's deportation, speaks louder than the rights of twenty abductees. Perhaps an unintended result of our education in China is that while the guides are well trained in showing a benign puppeteer manipulating the people and culture for the benefit of all, we can't help but see the puppeteer as tyrannical and be concerned for all Chinese artists, reporters, protestors, and others who dare to disagree with the party line.

China has enormous people power in its captive society but an oppressive approach to dissidents. Telling for us was the art district in Moganshan, where we saw little evidence of vitality, challenge through satire, and innovation. Thus, while China will continue to be an economic power and the world's fulfillment house, it will only be a country of copycats, combining Western technology and its massive labor force to cheaply produce goods until such time as the political system evolves beyond totalitarian rule. What

PHOTOGRAPHER'S STATEMENT

The mysterious East, resplendent with ancient temples, walled cities, elaborate brocade weaving, ink brush drawings of serene wildlife and exotic landscapes, exquisite Ming Dynasty ceramics and ornate porcelain, as well as graceful calligraphy, a dance of ink and brush on paper and cloth…. These art forms of ancient China are carried into the present. Even Marco Polo and others venturing along the Silk Road, bringing back exquisite objects discovered in their encounters with this strange world, remain infused with romance and excitement in today's world.

Exploring the Silk Road and Tibet like travelers of the past was part of our desire to make this magical journey, as was the yearning to witness the impact rapid change has had on this enormous country since opening itself to the West over forty years ago. From most world economic reports, China is poised to be a contender for world power. This convinced us that its contemporary art might be even more provocative than the artistic forms of antiquity deeply embedded in the country's fabric.

Upon our arrival in Shanghai, we were eager to get to Moganshan Road, a district celebrated for exhibiting the best contemporary Chinese art. Thrilled to be in this young and vibrant city that never sleeps, with as much neon as Las Vegas, we exhausted a day venturing from gallery to gallery in search of artwork to inform us of the culture and state of present-day China. But repeatedly

we were confronted with content that might be called "sofa art," decorative work with no artistic substance. Why wasn't China's story being told by the many stellar artists we had read about whose artwork was the newest "hot" investment in the art world?

During Mao's Communist reign of the 1950s, class struggle had replaced justice, allowing the government to maintain its power. Under these conditions, it was very difficult for anyone to develop a true awareness of self or aesthetic values. For a short time during the 1980s, after Mao's death, young Chinese artists began exploring nontraditional, benign art. These artists were allowed to work undisturbed until 1989, when the Tiananmen Square pro-democracy demonstrations occurred, as aired on television for the world to see. Though Deng Xiaoping, leader of the People's Republic of China until 1992, was all for "opening and reform," he established extreme totalitarianism with no freedom of expression, speech, or personal rights. His doctrine was aimed mainly at unlocking China's financial market, not egalitarianism and creative freedom. The government had tightened its control and not let go. Consequently, after Tiananmen Square many of the young emerging artists fled to Europe or the United States.

Today, China is still under totalitarian rule with very little room for freedom of expression. Although change is slowly unfolding, it is largely government initiated, the government is reaping the financial rewards, and the citizens feel they have no power over their destiny. "Those who are favored or directly associated with the government will be the winners," we were told over and

over again by the many individuals with whom we spoke. Even in large cities the majority of the population remains disgruntled and sees little hope for their future.

Although we took the trip without a political agenda, the culture's extreme oppression was soon apparent—from Xinjiang Province, where all outside communication was eliminated during strife between the Uighur and the Han Chinese in 2009 to the intolerance of separatist activities in Tibet to rage over the more recent awarding of the Nobel Peace Prize to Liu Xiaobo, who has been held in prison for his pro-democracy activities over the years. Although artistic comments about China's society and government are not tolerated by the ruling regime, the traditional art and craft of China does not pose a threat to the government so it is allowed to thrive. Also permitted is contemporary art in which some cities host international biennials, exhibitions of works chosen and scrutinized by the Communist Party, which itself, both past and present, is beyond reproach.

What is missing is art that turns a knowing eye on itself and society, emerging from a desire to promote progress. In a time when fear of punishment fosters silence, there is understandably no challenge or grit in the art. The "radical new" in art, which threatens most cultures at first glance, over time gains acceptance by informing its citizens and then by changing their lives. A progressive civilization only stands to flourish when the creative process is allowed to come to fruition from the hearts and souls of its artists.

ACKNOWLEDGMENTS

This book has been a work of passion for both Kathryn and me. We feel blessed to have traveled the ancient Silk Road and seen Tibet before modernization and the ticking of clocks leads to its inevitable change.

I would like to thank the people of China and Tibet for their constant kindness and mutual curiosity. They are proud people and deservedly so.

Next, I must thank my wife and cocreator, Kathryn. What fun we have learning together, and what a joy I have exploring with you! I look forward excitedly to our future journeys.

On my first day of law school, nearly four decades ago, the man on my right began a conversation that continues today. Thanks, Patrick, for sharing your love of literature and all things absurd. Our classmate Joe Hornblower soon joined in. They would have never figured I'd be the one to end up as an author.

My family has loved me through my adventures and miscalculations, never wavering in their support. Mother, Linda, Barry, Ann, Andrea, and Zach—thank you for always believing in me, even when I am way out of your comfort zones.

Additionally, my dear friends Abe, Evonne, and Jean continue to travel with me. We share paths of searching, evolving, truth, and learning—and always good food!

Over fifteen years ago, Carolyn Manosevitz listened to my poetry and encouraged my voice. She has continued to be a catalyst in my life.

I want to thank my editor, Ellen Kleiner, for creating order from chaos and leading me beyond any expectations for this book. Also, a deep thanks to my trusted friend Irene, who has guided us in our marketing efforts.

Finally, I am in constant gratitude for all the authors, artists, musicians, and English teachers who cultivated my love of creativity, music, and language, from Poe, Clemens, and Faulkner to Gauguin, Segovia, and the Beatles.

—STAN BIDERMAN

* * *

Collaborating on this book has been an amazing and educational journey for me as well, one I never envisioned undertaking. It is with these sentiments and heartfelt gratitude that I wish to offer loving thanks to my wonderful husband, Stan. You have pushed me beyond my comfort zone in this endeavor, and our laughter, joy, and loving partnership have enriched my soul immensely.

The trip was indelible largely because of the people of China and Tibet. Their curiosity about us, along with their smiles and knowing nods of the head in response to our mute communication, were signs of warmth and acceptance. My heart goes out to all the people of this vast country. May they someday be allowed to live in dignity and freedom from oppression.

My appreciation also extends to my dear friends Shirley and Jenni, who helped me navigate some arduous periods with a modicum of grace, offering

invaluable friendship. Also to Jenni, for her research on contemporary Chinese art that assisted me in articulating my thoughts and impressions.

To Janice St. Marie, who is a genius at designing beautiful, unique books. Watching her do her magic is miraculous. To her husband, Joe Mowrey, who put my photos "on the front burner" to make publication possible in a timely manner.

And lastly, to my family—Maury, Mike, Helen, Linda, Ann, Barry, Zach, and Andrea. Thank you for all your love and support. You make my life very rich, and I feel truly blessed.

—KATHRYN MINETTE

ABOUT THE AUTHOR

Stan Biderman served as Whole Foods' first lawyer; managed Book People, the largest independent bookstore in Texas; and pioneered the redevelopment of the south Congress area in Austin. Stan visited the Soviet Union in 1984 and has traveled throughout Western Europe, Morocco, Israel, most of Canada, New Zealand, Venezuela, the Caribbean, Central America, Mexico, and China. Also the author of *Everything Changes: A Spiritual Journey* (Plain View Press, 2006), he resides in Santa Fe, New Mexico, with his wife and collaborator, Kathryn Minette. Fascinated by the romance of the Silk Road, Stan and Kathryn recently traveled to its Western terminus in Istanbul and are planning a trip to Central Asia to further examine this ancient passage.

ABOUT THE PHOTOGRAPHER

Kathryn Minette taught art in New Mexico's public schools for fifteen years before becoming director of the Art in Public Places program, expanding the state's collection by more than two thousand artworks over twelve years. As director, Kathryn also implemented many innovative programs, which raised the caliber of public art across the state and generated national attention. An artist as well, she has worked in a variety of media throughout her career. Her home is in Santa Fe with her collaborator, fellow adventurer, and husband Stan Biderman.